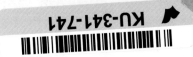

20th Century Painting

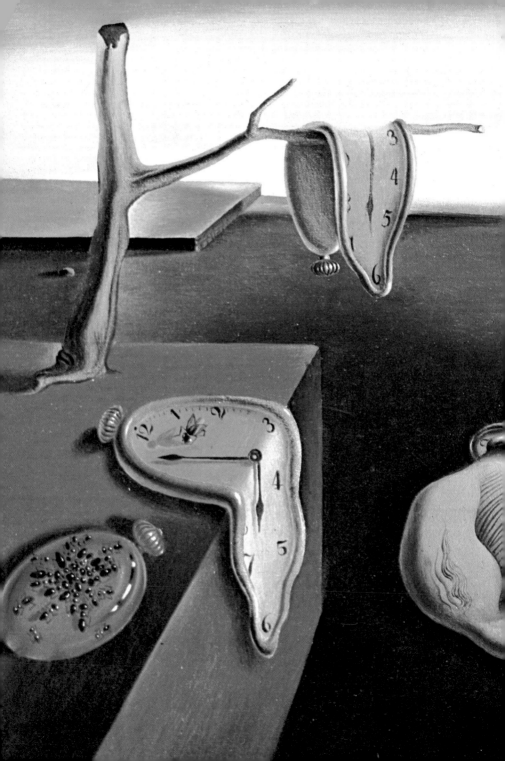

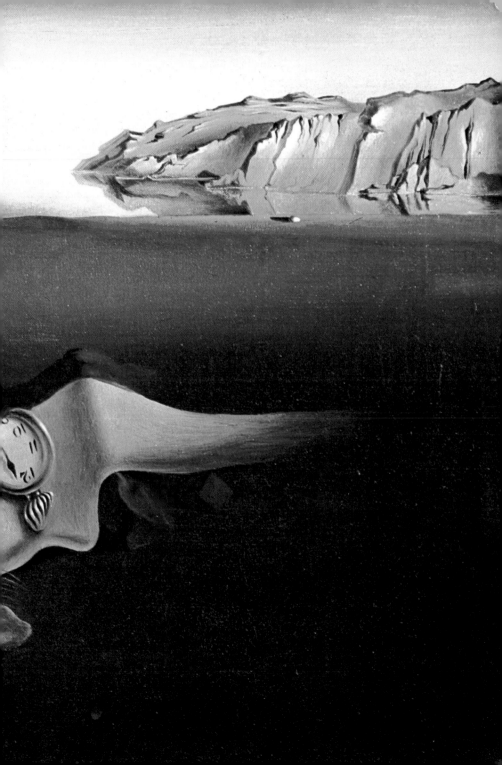

ABBEVILLE LIBRARY OF ART

20th Century Painting

BY

SAM HUNTER

Department of Art and Archaeology

Princeton University

ABBEVILLE PRESS

PUBLISHERS · NEW YORK

FRONT COVER (detail)
Woman with a Necklace by Amedeo Modigliani
Full picture on title page

FRONTISPIECE
The Persistence of Memory by Salvador Dali

Commentaries on page 112

PHOTO CREDITS
Page 19: Courtesy of Sotheby Parke Bernet; p. 25: Elton Schnellbacher; pp. 35–37, 87: Robert E. Mates; pp. 39, 45: Robert E. Mates and Mary Donlon; p. 41: © by ADAGP, Paris, 1979. Photo Stebler; p. 57: Courtesy Sidney Janis Gallery, New York; p. 61: Mike Tropea; p. 73: Allan Mitchell; p. 97: John Tennant

Library of Congress Catalog Card Number 79-57554

ISBN 0-89659-123-9

CONTENTS

AMEDEO MODIGLIANI
Woman with a Necklace
(detail).................................. Front Cover
Full picture on title page. *Commentary* 112

SALVADOR DALI
The Persistence of Memory..... Frontispiece
Commentary 112

HENRI ROUSSEAU
The Dream...................................... 16-17

PIERRE BONNARD
L'Heure des Bêtes: Les Chats
(Le Déjeuner des Bêtes)...................... 18-19

ANDRÉ DERAIN
London Bridge............................... 20-21

HENRI MATISSE
Odalisque with Raised Arms.............. 22-23

GEORGES ROUAULT
The Old King.................................. 24-25

ERNST LUDWIG KIRCHNER
Dodo and Her Brother...................... 26-27

OSKAR KOKOSCHKA
Hans Tietze and Erica
Tietze-Conrat................................. 28-29

WASSILY KANDINSKY
Improvisation No. 30 (Warlike
Theme).. 30-31

PAUL KLEE
Around the Fish 32-33

FRANZ MARC
Stables.. 34-37

GEORGES BRAQUE
The Portuguese 38-39

JUAN GRIS
Bottle of Banyuls.......................... 40-41

PABLO PICASSO
Three Musicians............................ 42-43

ROBERT DELAUNAY
Homage to Blériot 44-45

KASIMIR MALEVICH
Suprematist Painting..................... 46-47

FERNAND LÉGER
The City.. 48-49

UMBERTO BOCCIONI
Dynamism of a Soccer Player........ 50-51

GINO SEVERINI
Dynamic Hieroglyphic of the Bal
Tabarin (full picture and detail) 52-55

PIET MONDRIAN
Composition with Red, Blue,
and Yellow.................................... 56-57

MARCEL DUCHAMP
The Bride Stripped Bare by Her
Bachelors, Even (The Large Glass) 58-59

FRANCIS PICABIA
Amorous Parade............................ 60-61

KURT SCHWITTERS
*Merz Picture 25A: Das
Sternenbild* 62-63

GEORGE GROSZ
Eclipse of the Sun 64-65

MAX BECKMANN
Departure 66-67

MARC CHAGALL
I and the Village 68-69

CHAIM SOUTINE
Page Boy at Maxim's 70-71

GIORGIO de CHIRICO
*The Melancholy and Mystery
of a Street* 72-73

MAX ERNST
*Two Children Are Threatened by a
Nightingale* (full picture and
detail) ... 74-77

ANDRÉ MASSON
In the Forest 78-79

JOAN MIRÓ
*Person Throwing a Stone
at a Bird* 80-81

YVES TANGUY
Indefinite Divisibility 82-83

RENÉ MAGRITTE
Promenades of Euclid 84-85

ALBERTO GIACOMETTI
Diego ... 86-87

JEAN DUBUFFET
Promenades en Touraine 88-89

FRANCIS BACON
*Study Number 6 After Velazquez's
Portrait of Pope Innocent X* 90-91

JACKSON POLLOCK
Blue Poles 92-95

WILLEM de KOONING
Woman, Sag Harbor 96-97

GEORGIA O'KEEFFE
Yellow Cactus Flowers 98-99

MARK ROTHKO
Untitled 100-101

VICTOR VASARELY
Vonal-SZS 102-103

ROBERT RAUSCHENBERG
Retroactive I 104-105

JASPER JOHNS
Passage II 106-107

ANDY WARHOL
Electric Chair: Four Canvases 108-109

FRANK STELLA
Sinjerli Variation I 110-111

INTRODUCTION

TODAY, THE GENERAL PUBLIC still questions the meaning and values of modern art. Although the topic is not nearly so controversial as it was early in the century, when the Armory Show first scandalized large American audiences by showing the work of Cézanne, Picasso, Braque, Matisse, the Italian futurists, and other innovative modernists, nevertheless, a residue of mistrust and antagonism remains. The absence of recognizable subject matter, the distortion of the human figure, its frequent replacement by arbitrary abstract structures or by dreamlike fantasy—these and many other aesthetic strategies perplex and sometimes offend viewers accustomed to traditional forms of pictorial realism. There are no simple or absolute answers to the question: "What is modern art?" However, some useful definitions can be offered which may make modern paintings more intelligible to innocent viewers and enrich the experience of even a sophisticated audience.

The underlying development of twentieth-century painting, which is the time frame of the work this book includes, can be best understood under four major headings: *expression, perception, structure,* and *fantasy.* These categories hold out the promise of equally rewarding insights on the level of concrete visual interpretation and ideological relevance to the main currents of thought. In the text that follows, they have been interpreted within the framework of the differing viewpoints of the artistic movements and schools of twentieth-century art.

The art of expression was first announced by the explosion of Fauvist color in the celebrated Salon d'Automne of 1905, where

Matisse, Vlaminck, Derain, and others showed their startling new works to Paris audiences. Their colors were so raw and declamatory and their handling so apparently willful and savage that they were labeled "Fauves," or wild beasts, by a derisive critic.

Technically, Fauvism represented the confluence of the painting of Gauguin, van Gogh, and Cézanne. From van Gogh the Fauves derived their intense, pure color, violent harmonies, and energetic handling; from Gauguin, a synthetic principle of composition, expressed in the powerful and decorative opposition of flat planes; and from Cézanne, a new mode of expressing spatial relationships through color. Their art also represented a return to nature and to the natural. After the preoccupation of the *fin de siècle* with symbolism, with ideals of sensitivity, malaise, and spirituality, Fauvism posed new alternatives, vigorously asserting the outward physical man, intoxicated with his own sensations of the world and compelled to experience everything freshly.

EXPRESSIONISM

In Germany the Fauve revolution was given more vehement emotional and psychological content in the painting that is officially described as "expressionism"—the preeminent art of expression. The word was first used in Berlin in 1911 by Herwarth Walden, publisher of the avant-garde review *Der Sturm,* and he applied it loosely to include all the revolutionary tendencies between 1910 and 1920. The seeds of expressionism had been planted by van Gogh and even more decisively by the art of Munch, with its psychological penetration, grotesque imagery, and preoccupation with illness and death.

In 1905 three artists in Dresden, Ernst Ludwig Kirchner, Karl Schmidt-Rottluff, and Erich Heckel, exhibited together, calling themselves "Die Brücke" (The Bridge), a title meant to convey their sense of art as a link between the present and all the viable expressive forms of the art of the past, including primitive cultures. They were joined in 1906 by Pechstein and Nolde, and later the group reestablished itself in Berlin. There, in a climate of prewar tensions and under the impact of life in the great capital, their painting became more stridently emotional and more extreme in its self-awareness. The crisis atmosphere of the period produced in their work the real beginnings of German expressionism, with its wild distortions, fantasy, preoccupation with suffering, and feverish search for an inner reality.

In subsequent years expressionism gained a variety of inflections, ranging from the tortured, introspective content and excruciating nervous touch of the Austrian Kokoschka to the emotive abstrac-

tion and essentially mystical inspiration of Kandinsky's rhythmic color structures. Painting methods that place a premium upon vehement brushwork, distortion, and simplification can be linked to the term expressionist, even when they are nonrepresentational. The group of American painters after World War II, led by Pollock and de Kooning, who sought to intensify their own and the viewers' experience by the velocity of their gestural marks and their fragmentation of form were appropriately known as abstract expressionists.

We often find that an art attracted to extreme physical means and gesture reflects social as well as internal stress. In terms of modern psychology, Freud's disclosures of the turbulence of the conflicted neurotic personality may be considered the intellectual prophecy of expressionism. However, this no more means that such examples of modern art are neurotic than the battle panoramas or scenes of physical violence by artists as different as Rubens, Delacroix, and Goya would lead us to infer that their creators were a bloodthirsty lot. Expressionism is a universal feature of certain kinds of art throughout history. It cannot even be limited to the compulsions of modern psychology. In one of his letters, van Gogh discussed the various ways artists have tried to paint and concluded: "But what is the importance of such differences, when, after all, *the only thing that*

matters is the force of one's expression." The tumultuous energy that pours out of van Gogh's landscapes is matched by the sensual extravagance of Soutine's brushstroke and the opulence and violence of de Kooning's women-cum-landscape. In each case, the effect is startling, disturbing, and unforgettable.

THE NEW VISION:
CUBISM AND CONSTRUCTIVISM

Conditioned by late nineteenth-century impressionism, we might be inclined to understand our second category, perception, as a function of optics—a fugitive vision based primarily on observation of the world of sight and translated into a scintillating field of vivid color patches. While twentieth-century cubism preserved impressionist and neo-impressionist brushstroke, touch, and pulsation, the range of meanings for perception was extended to include a radical new sense of the external world. Shifting psychological viewpoints—a complicity of events, pictorial concepts, and even "states of mind," in futurist parlance—were understood to contribute to our sense of reality. The objects that are fragmented or set in motion by the cubist art of Picasso and Braque, and by the even more volatile art of the futurist Boccioni, occupy a space-time continuum made possible no doubt by Einstein's discov-

eries. What we see is distinctly co-ordinated with, and conditioned by, our personal vantage point.

The pictorial results of these new perceptions early in the century played havoc with conventional ways of seeing, and affected our third category, that of structure. The cubists dismembered objects and offered simultaneous views of a number of different aspects of their forms: in profile or architectural elevation and in plan; in full-bodied mass and as a transparent volume. But their visual revolution was not merely arbitrary, for it corresponded to new developments in the realm of science. Experimental physics challenged the naive realism of Newtonian space and time and postulated the equivalence of matter and energy. A radical empiricism in scientific thought and formal experiment in literature and art in the first decade of the new century, supported by the general optimism about the possibilities of modern technology, created an atmosphere favorable for testing a revolutionary interpretation of visual facts. Cubist and futurist painting were thus allied to a more general effort, manifest in many fields, to reexamine the structure of the modern world even at the risk of destroying traditional assumptions about the structure of the art object.

Cubism had made it clear that painting was an autonomous aesthetic entity—not an open window but a flat surface, itself an ob-ject in the world of objects, upon which a structure analogous to reality but not identical with it had been assembled. First in Russia and then in Holland, cubism led directly to a geometric abstraction from which even oblique references to the world were eliminated. In Holland Mondrian developed a severe rectilinear style with uniformly colored rectangles in the primary hues of red, yellow, and blue against a grid of black lines. Curiously, even the extreme rationalism of Mondrian's structures embraced a mood of utopian romanticism. Mondrian insisted that his art was a kind of engineering of content and belief in "a more equilibrated and therefore really beautiful future."

DADAISM

Cubism led in one direction to a rationalist, structured abstract art, but it also provided the formal basis for an antithetical reaction of disorder, disenchantment, and desperate high jinks in the movement known as Dadaism. Although it grew directly from cubism, futurism's more hysterical embrace of the modern world began to raise serious questions about the individual's competence to master the machine, and indeed suggested certain doubts about the prospects of individualism in the age of technology. World War I introduced in Europe a new mood of anxiety and skepticism. The formal language of cubism in 1914 began

to show mock-sinister overtones and a chimerical imagery. Picasso's constructions and collages of this period reveal bizarre configurations that have more than a plastic motivation; they are destructive puns on the theme of the absurd.

A new sardonic spirit and irrational fantasy took command of the paintings of Picabia and Marcel Duchamp about the same time. In 1912 Duchamp completed his famous *Nude Descending a Staircase*. Although still painting within the cubist formal vocabulary, Duchamp began to exploit extrapictorial associations, so that his geometrized figure in motion suggested in metaphor the conquest of man by the infernal machine and established a relationship between the mechanized world and the induced robotlike action in his figure. In 1914 Duchamp invented his first so-called "ready-made," a commercial bottle rack signed as a work of art. This enigmatic object both expressed a contempt for Victorian notions of beauty and also played on the incongruities of chance associations.

Duchamp's spirit of revolt gained new adherents and a program with the formation of the Dada movement in Zürich in 1916 by a group of poets and artists: Hans Arp, Tristan Tzara, Hugo Ball, and Richard Huelsenbeck. Dada was a form of serious artistic buffoonery and expressed the general spirit of negativism and even despair in a war-wracked age. The movement spread from Zürich to Germany and then to Paris, where Dada became the basis of surrealism in 1924. Among the many important artists who were either officially or indirectly associated with the movement were Hans Arp, Max Ernst, George Grosz, Kurt Schwitters, Paul Klee, and, somewhat later, Joan Miró. Some of the mercurial forms of Dadaist art were Arp's collages and reliefs; the *Merz* constructions and collages of Schwitters; George Grosz's violently satirical attacks on the moral corruption of postwar German life; and the witty and fantastic abstract imagery of Klee and Miró, before 1930.

SURREALIST FANTASY

Surrealism was a direct outgrowth of Dada but substituted for that wartime expression of exasperation a more constructive romanticism. It was born in a period of growing stability of faith and thus in a sense tried to revive some of Dada's controlled lunacy and techniques of public mystification as an antidote to complacency. Surrealism was the last outstanding movement in European painting and represents the last effective collaboration between artists and poets in this century. In 1924 André Breton, poet and former doctor, issued the first surrealist manifesto; in it he defined the movement as "a psychic automatism by which we propose to express the real functioning of thought . . . a dicta-

tion of thought without any control by reason, outside all aesthetic or moral preoccupations."

Two artistic styles in particular found favor with the surrealists. One is typified by Salvador Dali's creations, a meticulous, academic manner which "illustrated" improbably marvelous or frightening dream imagery in "hand-painted photographs." The anomalous juxtaposition of disquieting images became stock-in-trade devices used not only by Dali and Max Ernst, but later by the Belgians Paul Delvaux and René Magritte. Ernst officially incorporated into the surrealist catechism the poet Lautreamont's view that the new beauty must shock and astonish by its incongruities in describing his own imagery as "the fortuitous encounter upon a nonsuitable plane of two mutually distant realities."

Another surrealist manner opposed the visual illusions of Dali, Magritte, and Yves Tanguy with a nonfigurative, "automatic" writing, best exemplified in the fanciful curvilinear style of André Masson. Any imagery that emerged in Masson's art was merely a by-product of a free and unconscious activity of the hand and of the creator's sensibility. Such techniques were allied to the free curves and the casual arrangements of "biomorphic" forms in the Dadaist art of Hans Arp, and to the haunted collages and *frottages* that Max Ernst created during and immediately after the Dada period.

A number of surrealists, including Masson, Ernst, Tanguy, and Matta, lived in New York during the war years as refugees from Hitler's barbarism. Matta was the youngest and designated last "official" surrealist. He had a significant impact on Gorky, Motherwell, Pollock, and other members of the emerging American avant-garde. By 1947, however, most of the European surrealists had returned to France, and their influence was on the wane in the face of an increasingly independent American achievement. Pollock's breakthrough to his so-called "drip" style of abstraction was symbolic of the change and helped establish the authority of American "action painting," or abstract expressionism. Painting was now conceived as a spontaneous and open-ended action, where forms were generated ex nihilo, freely invented in the painting "act." Existentialist engagement in the process of painting had replaced the surrealist commitment to dream and the unconscious. It was thought that only as the artist emptied his mind of all preconceptions and applied pigment with utmost spontaneity would the images he made be an expression of the deepest levels of his being.

Opposed to the free, gestural abstractions of Pollock, de Kooning, Hofmann, and others were the large "color-field" paintings by Barnett Newman, Clyfford Still,

and Mark Rothko. Their canvases were intended to subdue the spectator's ego and create a sense of tranquil awe—to assert the "sublime" and thus to create a more exalted, if remote, sense of art than the activist, messy canvases of de Kooning and the gestural expressionists had done. In Europe, a postwar generation devoted to *"art informel"* emulated the example of the American abstract artists. However, there were such notable exceptions in figurative styles as Francis Bacon, with his nightmarish, surrealist-tinctured portraits, and Jean Dubuffet, whose deliberately naive and powerfully expressive canvases struck an uneasy balance between primitivism and sophisticated abstraction.

Since the 1950s new movements have proliferated as old schools stagnated, and many challenging concepts have been advanced that question the very nature of the art object and the commercial structure of the art world. Most of these provocative ideas are embodied in pop art, in a severely reductive minimalist abstraction, in "earthworks" of vast dimension constructed on remote terrain, in performance art, and in imperceptible art forms that exist primarily as language or "idea" rather than tangible material form.

A profound shift in attitude has inspired the continuing flow of innovation by some of the most fertile minds in European and American art through the 1970s. New concep-

tions of art as idea and action, as information rather than product, and as an intangible state of awareness have all proven their viability. An assumption underlying the most adventurous contemporary art forms is rooted in the rejection of the status quo not only in art but in emotions and politics. Like the revolutionary manifestations of earlier twentieth-century art movements, the succession of dominant trends from 1945 to the end of the 1970s, from abstract expressionism to environmental systems and conceptualism, are motivated by an ingrained experimentalism endemic to all modern art.

The avant-garde's restless tendency to push ideas as far as possible by expanding the frontiers of artistic experience and individual consciousness today continues to produce an unabated flow of significant art. The rate of major innovation and perhaps the number of individuals of genius have diminished by comparison with the first postwar pinnacle of greatness in the work of Pollock, de Kooning, Rothko, Bacon, and Dubuffet. Yet the energy level and sheer numbers of serious and talented artists today who are engaged in redefining the scope and meaning of the artistic enterprise is, if anything, more challenging intellectually—and perceptually —than it was thirty years ago at the beginning of the first great postwar artistic renascence.

Henri Rousseau (French, 1844–1910)

THE DREAM 1910

Oil on canvas, 80½ × 117½ in (204.5 × 297.5 cm)

Collection, The Museum of Modern Art, New York · Gift of Nelson A. Rockefeller

HENRI ROUSSEAU WAS a Paris customs official with a taste for music and painting. He retired from government service in 1885 to live on a modest pension and thereafter devoted himself entirely to painting. From 1886 he exhibited regularly at the Salon des Indépendants, much to the astonishment of most critics, who found his untutored, "naive" painting utterly ludicrous. The more discerning partisans of advanced art, such as Gustave Coquiot and the painter Redon, however, as early as 1888 praised his "noble classical style."

Rousseau belongs as much to the twentieth century as to the nineteenth, and especially to the period of cubism, when his authoritative formalism was appreciated despite its obvious primitivism. *The Dream* was the last painting he made, and he described it thus: "This woman asleep on the couch dreams that she has been transported into the forest, listening to the sounds of the enchanters' instruments." The luxuriant tropical scene was perhaps an imaginatively heightened memory of the Mexican jungles Rousseau had seen in his youth during his participation in Maximilian's campaign. There is subtle drama, not without Freudian overtones, in the interaction of the gorgeous flora and fauna of this mysterious jungle-Eden, the chaste nude figure, and the vague menace of the moonstruck lions, elephant, and pink serpent. In his youth Rousseau had had an amorous escapade with a Polish woman whom he thenceforth privately referred to by the name of Yadwigha, the same name he gave to the nude in this painting.

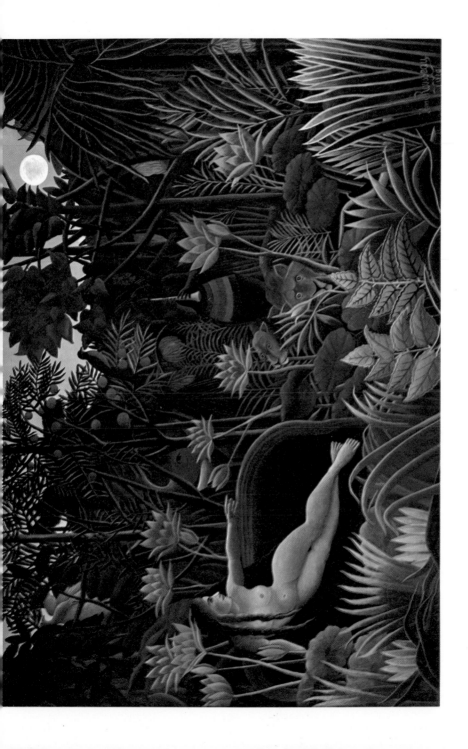

Pierre Bonnard (French, 1867–1947)

L'HEURE DES BÊTES: LES CHATS 1906
(Le Déjeuner des Bêtes)

Oil on canvas, 29½ × 42½ in (75 × 108 cm)

Collection of Mr. and Mrs. Suna Gershenson, Mexico City

PIERRE BONNARD IS A belated impressionist whose art, like Rousseau's, bridges the nineteenth and twentieth centuries; it probably reached its most sumptuous flowering in the decade of the 1930s. He was one of the founders of the Nabis, a group of followers of Gauguin. In the 1890s he emulated their master's simple and non-naturalistic colors and increasingly abstract compositions. Bonnard and his associate Édouard Vuillard later adopted the broken, flecked brushwork of the impressionists and returned to their bourgeois backgrounds, abandoning the self-conscious primitivism and mystical subject matter of the other Nabis.

Their unassuming interiors, with family members or intimate friends shown reading or working at banal domestic tasks, are treated with humor and tender affection, but also with an almost awesome tranquility that is echoed in classical, stable compositions. Here, the friezelike arrangements of still-life objects on the table and the cat in repose stabilize the lively business between the woman and her feline playmate. Through the work's glowing chromaticism, this intimate and charming domestic scene expands into a universal poetry of light.

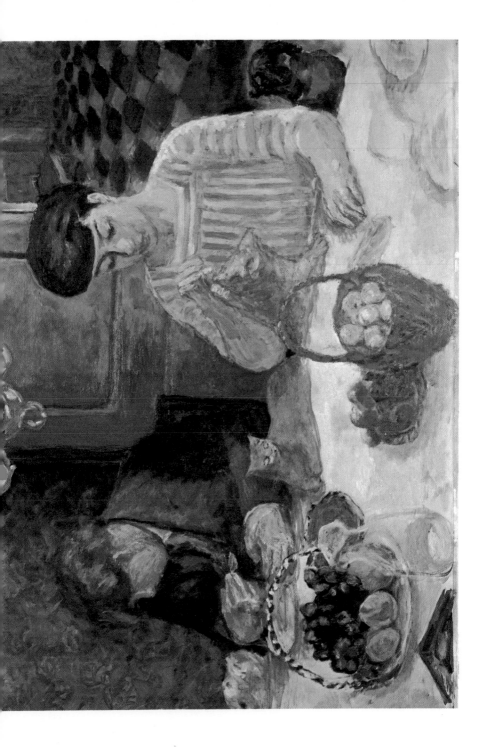

André Derain (French, 1880–1954)

LONDON BRIDGE 1906

Oil on canvas, 26 × 39 in (66 × 99 cm)

Collection, The Museum of Modern Art, New York · Gift of Mr. and Mrs. Charles Zadok

IN 1905 ANDRÉ DERAIN joined Matisse, Vlaminck, Marquet, and others in the first Paris exhibition of the "Fauves," or "wild beasts," as journalists dubbed the new group of revolutionary colorists. By the second year of activity as a Fauve, he had, like many of his associates, added a more compact and solid design to the exuberance of his colors. *London Bridge* is organized by the architectural structure of the bridge, and by the vertical and horizontal accents of the buildings in the background. The brilliance of the color and the particular dissonant color chords of chrome yellow and orange set against deep blue recall the vehement chromatics of van Gogh, whose paintings both Vlaminck and Derain particularly admired at this time.

Unlike Vlaminck, with whom he was perhaps most closely associated in his early years as a painter, Derain made a point of applying analytical intellect as a constraint on his more spontaneous emotions. "If you rely on the sheer force of the color as it leaves the tube," he remarked, "you won't get anywhere. That's a theory for a dyer." Yet he understood perfectly the necessity for the Fauve liberties and explained them with precision. Referring to his Fauve "ordeal by fire," he wrote in retrospect: "It was the era of photography. This may have influenced us, and played a part in our reaction against anything resembling a snapshot of life. No matter how far we moved away from things, in order to observe them and transpose them at our leisure, it was never far enough. Colors became charges of dynamite. They were expected to discharge light. It was a fine idea, in its freshness, that everything could be raised above the real."

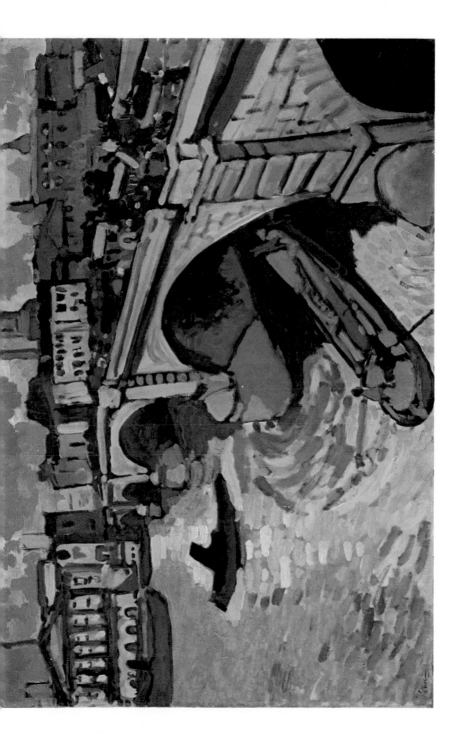

Henri Matisse (French, 1869–1954)

ODALISQUE WITH RAISED ARMS 1923

Oil on canvas, 15½ × 19¾ in (39.4 × 50.2 cm)

National Gallery of Art, Washington, D.C. · Chester Dale Collection

Aᴏᴛᴇʀ 1917, ᴡʜᴇɴ ʜᴇ began to winter at Nice, Matisse's painting became more "realistic" and anecdotal, perhaps in obedience to the general postwar reaction that found artists all over Europe returning to a more conventional, "humanist" vision. Early in the twenties Matisse began to paint the odalisque themes that were to be a major part of his artistic production during the next decade. *Odalisque with Raised Arms* was one of the first, and it is a particularly ingratiating one, with its vivid but lightened colors and thinnish medium. Few of the painter's tones are fresher than the rosy flesh color of the nude, which makes a controlled, vibrant harmony with the cool green striping of the chair and the pale gray-green wall hanging. The cool colors are admirably balanced against the warm orange-brown floor tone and the red flowered print in the background. Matisse builds up a variety of different running patterns, a discreet and subtle profusion of stripes and flower figures, but rests the eye in the blank, rectangular intervals of the ocher wall. In a similar fashion small, busy detail is balanced off against wide stripes, little repeated curves against broad, sweeping arcs. The effect is of a controlled scintillation of color and light within a design that is both masterful and coherent.

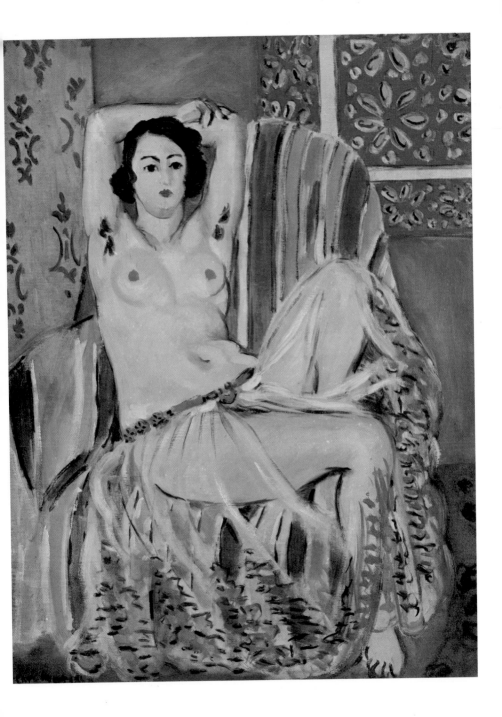

Georges Rouault *(French, 1871–1958)*

THE OLD KING 1916–1936

Oil on canvas, 30¼ × 21¼ in (76.8 × 54 cm)

Museum of Art, Carnegie Institute, Pittsburgh

GEORGES ROUAULT WAS INFLUENCED first by the savage carica-
ture of Goya, Forain, and Daumier, then by the new freedom of
expression that Matisse and the Fauves brought to art. In 1905
he joined the Fauves in their first joint exhibition, but his
moralistic subject matter of prostitutes, his murky blue washes,
and overwriting with an expressive network of black lines were
far removed from their blithe hedonism. Rouault's somber
mood and religious preoccupations isolated him from the main
currents of the art of his time. He once declared, "I do not feel as
though I belong to this modern life . . . my real life is back in the
age of the cathedrals." From the Gothic cathedral, in fact, he
adapted the most striking feature of his technique, the effect of
translucent, glowing color and heavy contour lines which
strongly resembled the leaded stained glass he so admired.

The Old King vies with Soutine's creations for coloristic splen-
dor. It was probably begun in 1916, put aside during Rouault's
lengthy printmaking period, and completed in 1936. It is a more
sumptuous and tranquil image than his early prostitutes, but it
still has an angular, unwelcoming quality, what James Johnson
Sweeney has called a "Celtic unfriendliness." The image suggests
the subject's avarice and meanness of spirit, but the artist's
savagery has softened somewhat in the direction of lyricism with
his advancing age.

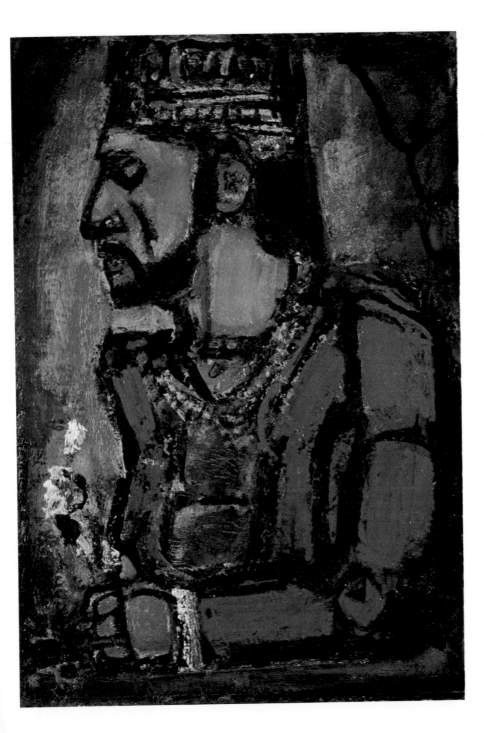

Ernst Ludwig Kirchner (German, 1880–1938)

DODO AND HER BROTHER ca. 1908

Oil on canvas, 67⅛ × 37⁷/₁₆ in (170.5 × 95 cm)

Smith College Museum of Art, Northampton, Massachusetts

ERNST KIRCHNER WAS the acknowledged leader of the first group of German expressionists, formed in 1905 and called "Die Brücke" (The Bridge). Their work corresponded closely to that of the French Fauves in its uninhibited color, emotional intensity, slashing lines, and distortions. Although it is not always readily apparent, the German group—which included Nolde, Heckel, Schmidt-Rottluff, and others—emphasized psychological and social meaning over formal considerations more than did the French. A self-conscious primitivism pervades their paintings not only in the deliberate crudity of technique, but also in the choice of subjects: the life of the streets, the naked form, male and female, often in a woodland setting. The subject matter was nearly always transformed, however, into new levels of meaning by the consistent distortion and bold, painterly treatment of the forms. Kirchner's work is characteristic, beginning with a kind of emotionally charged decorative style, very close to Fauvism— evident in *Dodo and Her Brother*—and then turning progressively to human commentary, to psychological exploration, and finally to a quieter, more formalized style related to cubism.

Oskar Kokoschka (British, born Austria, 1886)

HANS TIETZE AND ERICA TIETZE-CONRAT 1909

Oil on canvas, 30⅛ × 53¾ in (76.5 × 136.2 cm)

Collection, The Museum of Modern Art, New York · Abby Aldrich Rockefeller Fund

OSKAR KOKOSCHKA WAS the leading expressionist in Vienna after the turn of the century. Shortly after encountering the work of van Gogh in 1906, Kokoschka began a series of excruciatingly sensitive "black portraits," as the artist called them. They seemed to unmask and bare the souls of his uneasy sitters, who were often prominent personages in the social, intellectual, or artistic world of Vienna. The artist felt that his visionary portraits performed a kind of cathartic act of self-confrontation for his trancelike victim-sitters, which forced them, therapeutically, to surrender their "closed personalities, so full of tension," in his words.

"My early black portraits," he wrote, "arose in Vienna before the World War; the people lived in security yet they were all afraid. I felt this through their cultivated form of living which was still derived from the Baroque; I painted them in their anxiety and pain." The painter chose to reveal behind the cultivated façade his sitters' emotional and intellectual disequilibrium. It is difficult not to relate these remarkable disclosures of personality in conflict to Freud's studies of the role of the unconscious in human behavior and to his insistence, which took so long to gain popular credence, that psychic states could be represented through objective, scientific formulation of fact. After World War I, however, Kokoschka's art became less feverish as he was drawn to Cézanne, and more hedonistic color schemes dominated his palette. A new sense of optimism, reflected in the luxurious color, came to the fore.

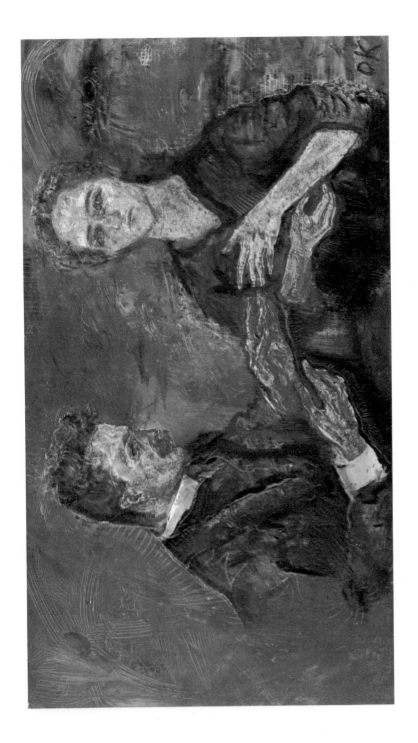

Wassily Kandinsky *(Russian, 1866–1944)*

IMPROVISATION NO. 30 (WARLIKE THEME) 1913

Oil on canvas, 43¼ × 43¼ in (109.9 × 109.9 cm)

The Art Institute of Chicago · Arthur Jerome Eddy Memorial Collection

LED BY WASSILY KANDINSKY, a Russian expatriate, a group of artists that included Gabriele Münter, Franz Marc, and later Paul Klee began to exhibit together in 1911 in Munich, and formed the second major German expressionist group, Der Blaue Reiter (The Blue Rider). They were far more sophisticated intellectually and less primitivistic in technique than the members of The Bridge. The Blue Rider emphasized the spiritual and symbolic properties of natural and abstract forms rather than the evocation of emotional intensity through color and distortion.

After painting rather freely distorted but still representational landscapes in opulent color, following the Fauve example, in 1910 Kandinsky began a series of purely abstract "improvisations," the first experiments in a free-form, nonobjective art of the new century. In *Improvisation No. 30,* however, done in 1913, one can decipher a cannon mounted on wheels, city buildings, and a mountain landscape despite the abstract tumult of his lines and colored forms. In 1911, he wrote "Concerning the Spiritual Art," which appeared in *Der Blaue Reiter,* a journal of aesthetic studies published by Kandinsky and Marc in 1912. This essay elaborated on his aesthetic theories and, for the first time, gave theoretical sanction to a nondescriptive art. Kandinsky's pioneering essay stressed the inwardness and intuitive qualities of artistic creation. Paintings, he held, should be created in a state of inner tension and looked upon as "graphic representation of a mood and not as a representation of objects." The spiritual and introspective aspects of his art and theory were to have a profound effect on the developing expressionist tendencies in Germany.

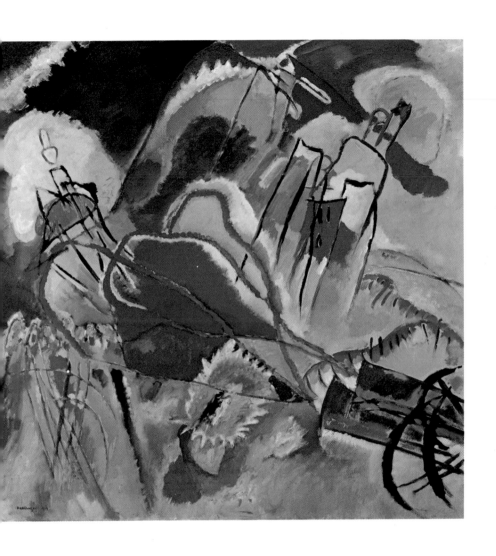

Paul Klee *(German, born Switzerland, 1879–1940)*

AROUND THE FISH 1926

Oil on canvas, 18⅜ × 25⅛ in (46.7 × 63.8 cm)

Collection, The Museum of Modern Art, New York · Abby Aldrich Rockefeller Fund

PAUL KLEE WAS THE MOST poetic, most original, and certainly the most singular artistic personality of The Blue Rider, although his relationship to their exhibition, activities and the theories of Kandinsky and Marc was tangential. He participated in the 1912 publication and exhibition and the following year arrived at a virtually abstract style. His art may best be understood as a form of poetic metaphor, a system of private signs that strive to attain universal meanings.

The symbolism of *Around the Fish* is not as obscure as it may at first appear. The submerged fish has an ancestral quality and can perhaps be taken as a symbol of universal consciousness; the man, to whom the arrow points, represents human consciousness, the tribulation of thought. Other symbols suggest nature, the sun, and the moon, even Christianity, in a kind of schematic evolutionary history of man, beginning with zoology and ending with religion.

Technically, Klee's art was extremely inventive and scarcely seemed to recognize formal limitations. In fact, he experimented freely with various pastiches of styles and with every sort of visual effect that came readily to his virtuoso hand. His art was childlike, deliberately artless and unspoiled even as it attained a rare degree of sophistication, and he obviously enjoyed this paradox. It is significant that Klee exhibited with The Blue Rider artists just as they were elevating the art of children to the level of social and aesthetic seriousness by illustrating examples of it in their almanac.

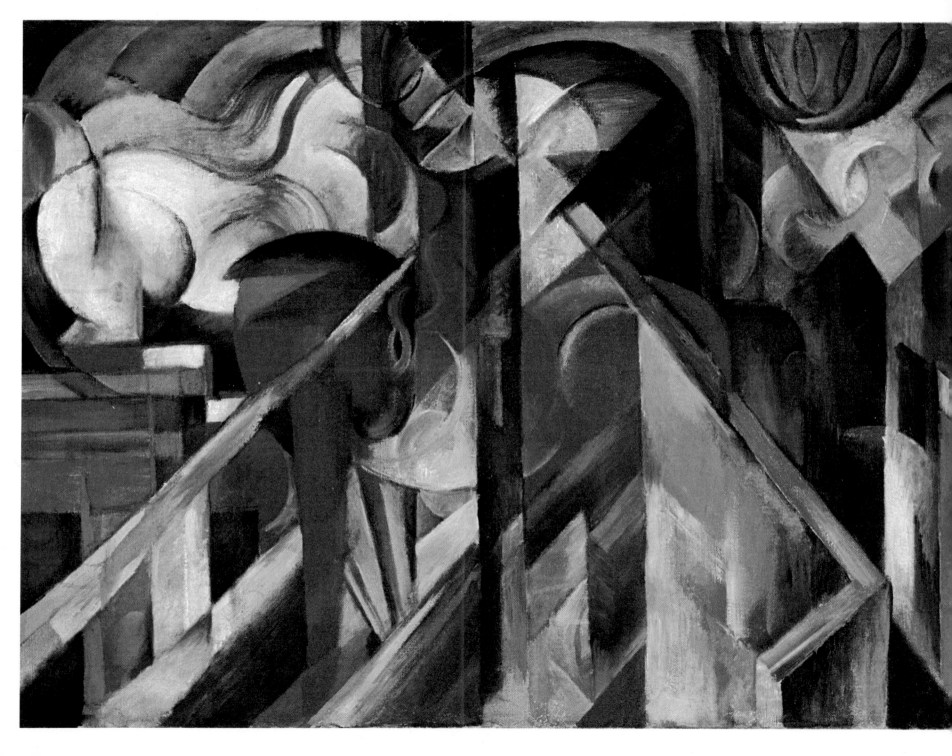

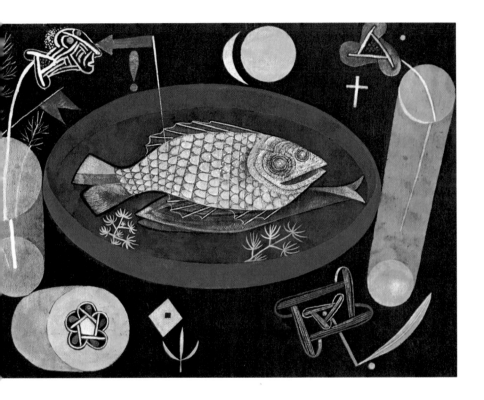

Franz Marc (German, 1880–1916)

STABLES 1913–1914

Oil on canvas, 29⅛ × 62¼ in (74 × 158.1 cm)

The Solomon R. Guggenheim Museum, New York

FRANZ MARC, LIKE HIS colleague Kandinsky, pursued spiritual and mystical values through art, but his symbolism identified feeling with animal existence in nature rather than with a purely abstract system of color forms. *Stables* represents an effort to convey this theme and to penetrate the animal spirit. Marc thus enriches the viewer's visual imagination with imagery that gives a new splendor to creatural fancy. We discern the haunches, curving necks, and lashing tails of horses tethered in a stable through a transparent cubist structure of triangulated color planes. Cubism provided the artist with a formal vocabulary, but his color symbolism, with blue conceived as the color of hope, transmits a sense of the underlying mystical design of the universe and articulates the great chain of being from animal to man to deity.

FOLD OUT HERE ▶

Georges Braque (French, 1882–1963)

THE PORTUGUESE 1911

Oil on canvas, 45⅞ × 32 in (116.5 × 81.5 cm)

Kunstmuseum, Basel · Gift of Dr. H.C. Raoul La Roche

THIS PAINTING IS A superlative example of the uncompromising and mandarin phase of "analytical" cubism, which managed to hold in elegant tension bits of observed or remembered subject matter and pure formal invention. No matter how fragmentary and remote, references to a human figure (probably seated), a guitar, and still-life objects are clearly discernible, as well as fragments of letters and numbers. In the language of modern abstraction, Georges Braque sought a fresh formal solution to the problem that so profoundly engaged French modern painting from Manet to Cézanne: the expression of three-dimensional reality within the limits of a flat picture surface. He kept his space fluid and alive by the variety of contrasting painterly touches in his accented planes; yet the cumulative impression is one of a solid structure, which becomes a legible symbol of a guitar player.

Beginning with *The Portuguese,* stenciled or commercial lettering appeared on the painting surface for the first time, to be followed at a later date by the trompe-l'oeil imitation of wood grains and varied textural effects normally alien to conventional painting methods. Such visual non sequiturs violated the traditional integrity of painting's "noble means." An effect of psychological surprise and dislocation was achieved by introducing fragments of reality out of context, but the cubists also stressed the physical reality of the painting surface with such strategies by giving the frontal plane a new prominence.

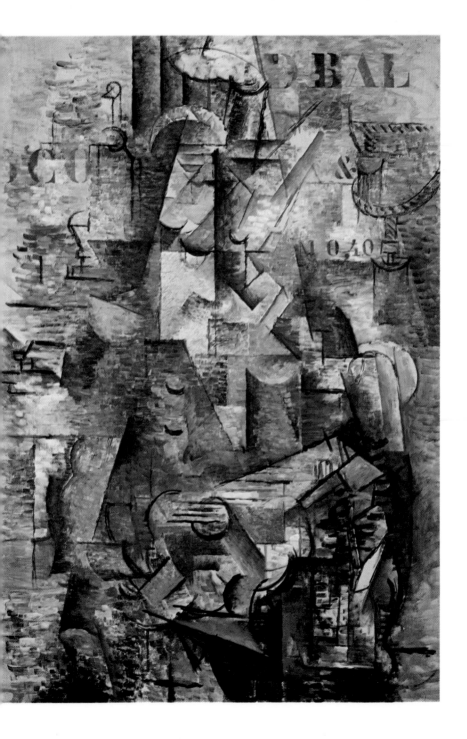

Juan Gris (*Spanish, 1887–1927*)

BOTTLE OF BANYULS 1914

Collage, pencil, and gouache on canvas, 21⅝ × 18⅛ in (55 × 46 cm)

Kunstmuseum, Bern · Herman and Margit Rupf Foundation

THE PURITY OF THE more austere and somber phase of analytical cubism in Europe soon gave way, around 1913–14, to more colorful forms of abstract expression that incorporated untransformed, raw materials or a variety of details selectively edited from external reality., The disruptive effect of juxtaposing newsprint and ticket stubs against a carefully worked painting surface seemed irrational and perverse at the time—or at best frivolous. Now it can be understood as a sincere and serious method of exploring new expressive possibilities while at the same time freeing the art object from the highly elitist associations of its fine arts status by restoring it to the commonplace environment. It was the first occasion in our century when the modern artist used a vernacular visual language to challenge the sanctity of high art.

These hybrid works of art—in part imaginative fiction and in part everyday visual prose—were known as *papiers collés,* or pasted papers, but they soon came to be called "collages" by artists and the wider public. Among them are some of the most beautiful and serious works of cubist art. *Bottle of Banyuls* is an extraordinary harmony of interlocking bright and sober color planes and subtle textures in conjunction with delicately muted, shaded drawing. All of this lends an air of fragile mystery to the banal fragments of the bottle's label, the newsprint, and the silhouetted pipe and glass.

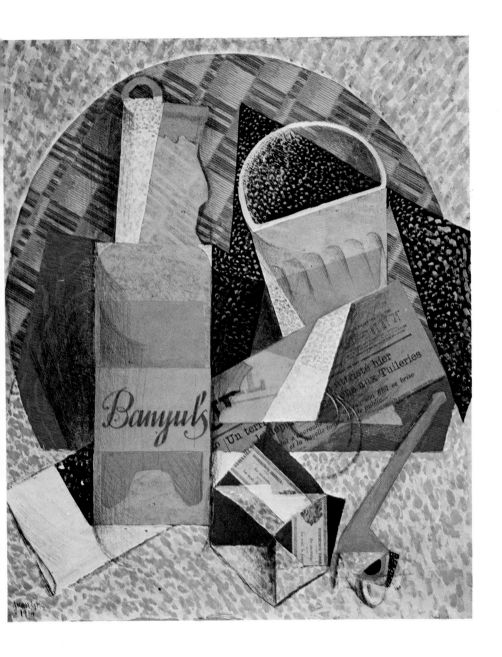

Pablo Picasso (Spanish, 1881–1973)

THREE MUSICIANS 1921

Oil on canvas, 79 × 87¾ in (200.7 × 222.9 cm)

Collection, The Museum of Modern Art, New York · Mrs. Simon Guggenheim Fund

IN 1921 THE VERSATILE and restless Picasso painted two monumental compositions with the same title, which can best be described as majestic wall decorations; they represent one of the summits of his career. The other variation can be found in the Philadelphia Museum of Art. Both works have developed from the small, uniform brushstrokes, faceted planes, and almost musical formalism of analytical cubism to a new phase of purely invented forms and interlocking, flat, colored shapes, which Alfred H. Barr, Jr. later dubbed "synthetic" cubism.

The figures recall a classical theme taken from the iconography of the commedia dell'arte. In the Museum of Modern Art's composition, a Pierrot at the left is playing a woodwind, a harlequin at the center plays a guitar, and a monk at the right, masked like his fellow performers, sings from sheet music in his lap. The simplicity of the theme is countered by the extraordinary intricacy of a system of spatially ambiguous, jigsaw-puzzle fragments and by the theatrical brilliance of the color. The painting also yields fantastic associations and even a touch of the sinister in its distortions. The ominous masked heads, diminutive hands, and the dog, or wolf, silhouette anticipate the dream-world imagery of surrealism, to which movement the shifting identities of cubist imagery contributed significantly.

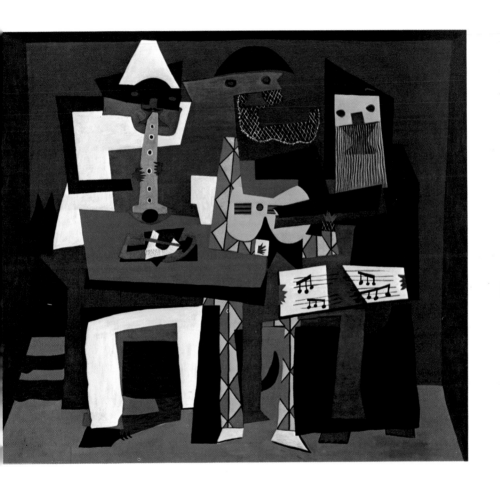

Robert Delaunay (French, 1885–1941)

HOMAGE TO BLÉRIOT 1914

Watercolor on canvas, 98½ × 98½ in (250.2 × 250.2 cm)

Kunstmuseum, Basel

In Paris, around 1912, the Frenchman Robert Delaunay, working with Franz Kupka, a Czech, developed a new form of geometricized, abstract color painting. *Homage to Blériot,* painted shortly after their invention, fuses the spectrum colors of Fauvism with cubist structural design in a new form of pure color abstraction which the critic Guillaume Apollinaire later called "Orphism." Using softened circular forms to orchestrate mystical intensities of radiant light, Delaunay anticipated some of Severini's and Balla's later abstract geometric representations of brilliant color patterns, which allude to the dynamic energies of modern life.

Delaunay and Kupka arrived at the first systematically abstract painting of the century, coincidental with Kandinsky's nonobjective improvisations in Munich. Their paintings preserved the triangular and circular segment forms of the cubists, but mellowed the edges of their arcs and planes into soft and glowing cores of light of graduated intensities. To link the idealized abstract style with Louis Blériot, an innovator in aerodynamics, seemed appropriate to Delaunay. Like so many of the artistic revolutionaries of his period, he associated progressive changes in art with the new world that advanced technology had opened to mankind.

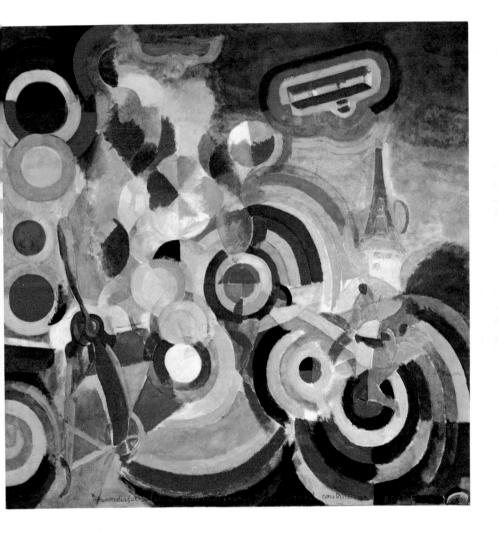

Kasimir Malevich *(Russian, 1878–1935)*

SUPREMATIST PAINTING 1915

Oil on canvas, 40 × 25¼ in (101.6 × 64.1 cm)

Stedelijk Museum, Amsterdam

GEOMETRIC ABSTRACTION DEVELOPED directly out of cubism, first in Russia about 1913 and then in the Netherlands in 1917. For both Kasimir Malevich and Piet Mondrian, cubism became a profound inspiration and then, surprisingly, an unsatisfactory halfway house en route to an absolute rejection of materialism and the objective world. By 1913, Malevich had worked his way through a variety of vanguard styles from symbolism to his own form of cubist collage. He termed his collages "nonsense realism," because they combined abstract structure and trompe-l'oeil fragments of actuality cut out with shears, all reassembled in a new and, at first glimpse, incoherent syntax. Increasingly devoid of particularities of textures and object definition, his painted squares and rectangles soon became the basis of a purely abstract art. He paradoxically defined his invention of nonobjective art, which he dubbed "suprematism," as "the supremacy of . . . feeling in . . . art."

Suprematism was perhaps the most revolutionary conception of its time in modern art. When Malevich painted his first radical abstract picture of a black square on a white ground, he explained it with a messianic fervor typical of the first generation of pioneer abstractionists: "In . . . 1913, in my desperate attempt to free art from the ballast of objectivity, I took refuge in the square." Although the forms of his suprematist paintings have now become part of an almost too familiar visual language of international abstract art, in his own time Malevich viewed them in a different light, as a key to universal knowledge. Kandinsky, Mondrian, and Malevich all shared this mystical sense of the high purposes and transcendental powers of nonobjective art.

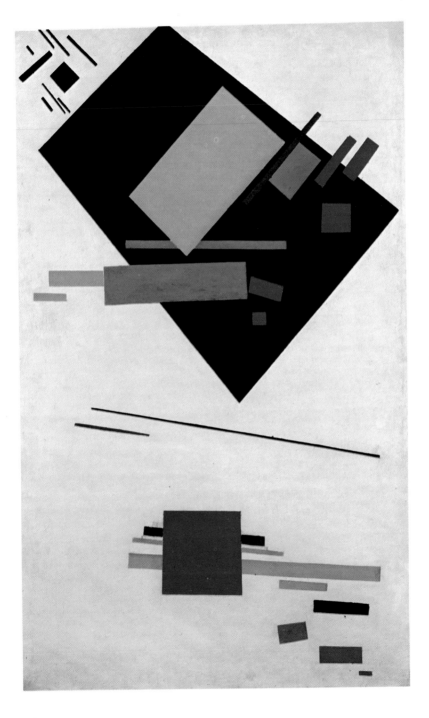

Fernand Léger (French, 1881–1955)

THE CITY 1919

Oil on canvas, 90¾ × 117¼ in (230.5 × 297.8 cm)

Philadelphia Museum of Art · The A.E.Gallatin Collection

Fernand Léger studied as an architect before settling on a career of painting. He worked closely with Le Corbusier, and they became lifelong friends. Léger's predilection for the clean, efficient forms of modern architecture and engineering are apparent in *The City,* perhaps his first major canvas on a grand mural scale and one of his most ambitious. His early attraction to a "machine aesthetic," which he championed systematically with Le Corbusier in later years, is evident in the robot-like figures ascending the stairway in the middle of the composition, and also in the resemblance of almost every decorative area to a variety of machinery parts: tubing, shafts, flywheels, casings, and so on. Léger's painting even suggests the up-and-down pumping or rotary motions of some smoothly functioning industrial machinery. He has animated this abstract arrangement by the rhythmic play of colored shape against shape and by his subtle divisions of the vertical spaces.

The City catches Léger emerging from synthetic cubism into a style of even greater breadth and easy articulation which could, in his words, "liberate color in space." He passed through many phases in subsequent years, arriving at a simple monumental style and an even happier balance of form and color; but few of his later paintings are more chromatically exciting than *The City.*

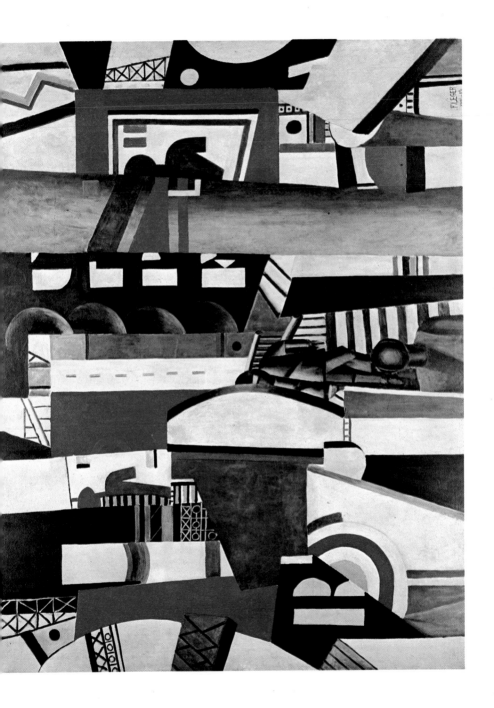

Umberto Boccioni (Italian. 1882–1916)

DYNAMISM OF A SOCCER PLAYER 1913

Oil on canvas. 76¼ × 79¼ in (193.4 × 201 cm)

Collection. The Museum of Modern Art. New York
The Sidney and Harriet Janis Collection. Gift to the Museum of Modern Art

UMBERTO BOCCIONI'S PAINTING idealizes the exertive effort and physical challenge of a violent sports encounter, much as the futurists glorified in word and image the life of action generally, even to the point of celebrating war. Such cultural preferences were part of a conscious program to escape the stagnant Italian past and to find new heroic themes more consonant with the modern age. Boccioni's high-colored and agitated jumble of figures has in fact been reduced to an abstract spiral of color forms and color space, greatly energized and yet almost sculptural in its palpable mass. Boccioni was the primary futurist theorist, and he supported paintings of this character with such statements as the following: "We conceive the object as a nucleus (centripetal construction) from which the forces (force-lines-forms) which define its ambience (centrifugal construction) depart, and thus determine its essential character." Although he is describing a perceptual event and a new pictorial concept, in fact, his statement could also be read as the schema for some kind of machine system.

From cubism's pictorial language of shifting planes, the futurists learned to break through the surfaces of objects to show them moving in space, and to make that movement reflect states of mind. Boccioni glorified the modern delirium of speed, and, with a perhaps undiscriminating appetite, swallowed the contemporary machine environment whole, discharging his new impressions in a kaleidoscopic art of force lines, vectored shapes, and mobile, shifting patterns.

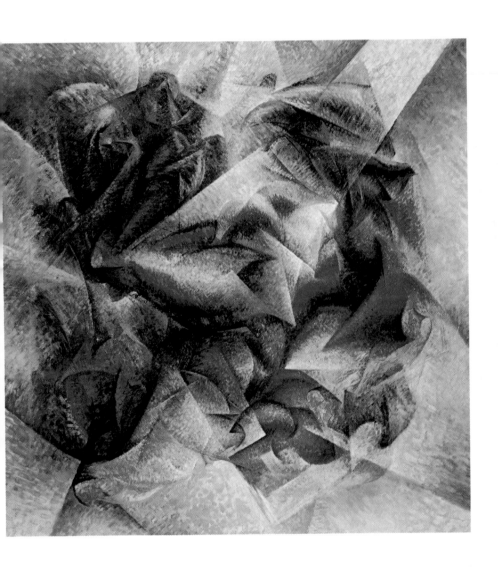

Gino Severini (Italian, 1883–1966)

DYNAMIC HIEROGLYPHIC OF THE BAL TABARIN 1912

Oil on canvas, with sequins, 63⅜ × 61½ in (161.6 × 156.2 cm)

Collection, The Museum of Modern Art, New York
Acquired through the Lillie P. Bliss Bequest

GINO SEVERINI WAS the most Paris-oriented of the futurists. He lived primarily in France after 1906, although he joined his fellow Italian artists and the poet Tommaso Marinetti in their preliminary manifesto of 1910 and shared their rejection of traditional values and their worship of the machine. He charged French cubist structure with a new bustle, glitter, and mobility. His dance hall scene with its dislocated fragments of gesticulating dancers was described by the artist as a spectacle with "dancers reflected in a fairy ambience of light and color." It is a more carefree and unprogramed version of modern life interpreted through the pursuit of pleasure. The painting combines neo-impressionist pointillist techniques with cubist spatial analysis, and its effect of studied artificiality is enhanced by the glitter of sequins sewn on the surface. Severini's sense of form is more lyrical than structural, however, at a time when cubism was becoming rigidly geometrical. The phrase "dynamic hieroglyphic" suggests that for Severini the scene of gay Parisian night life was less important than the abstract rhythmic forms and fluid motion, comprising an autonomous system of signs. In his writings, Severini theorized that these increasingly abstract ciphers gave universal meaning to the dynamic aspects of man's internal experiences.

52

FOLD OUT HERE

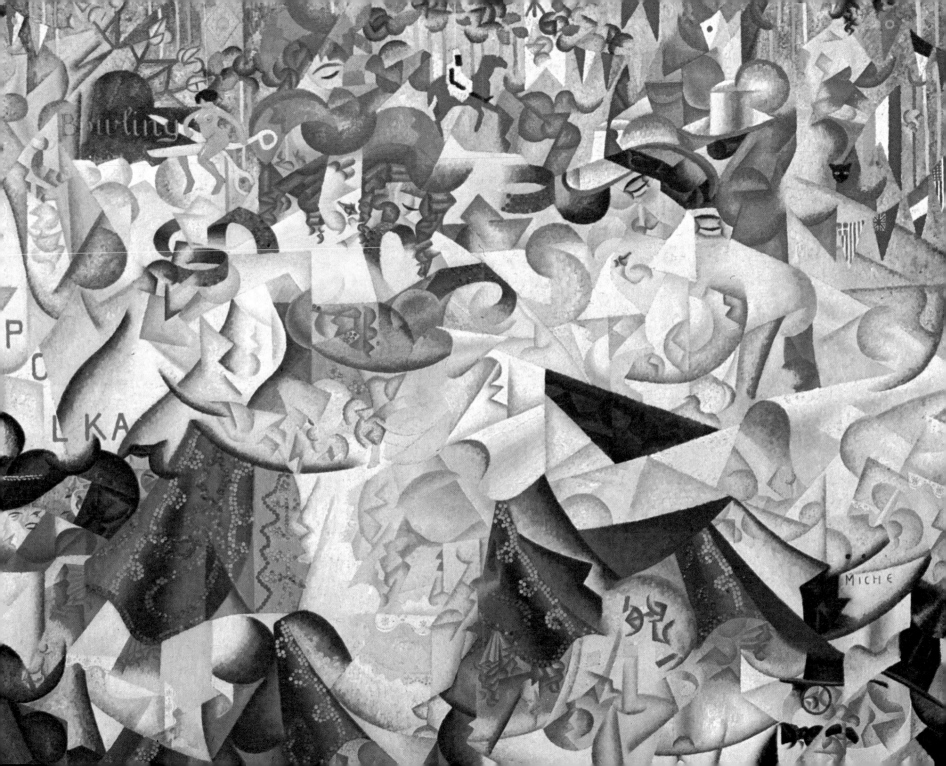

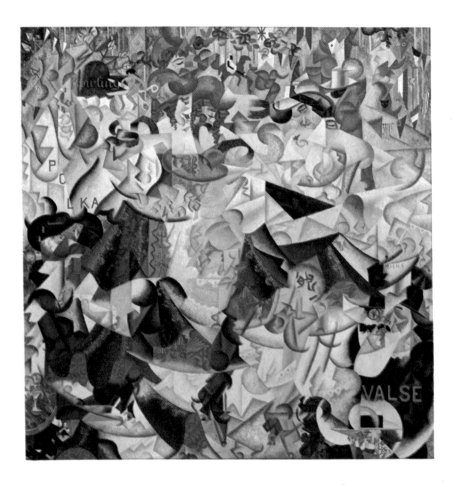

Piet Mondrian *(Dutch, 1872–1944)*

COMPOSITION WITH RED, BLUE, AND YELLOW 1928

Oil on canvas, 48 × 31 in (121.9 × 78.7 cm)

Private collection

AROUND 1928, MONDRIAN reached his mature style of an extremely simplified system of grids whose broad connecting planes were painted evenly in brilliant primary colors. Disposed in asymmetric balance, the colored rectangles were set against a ground of pure white. From that time until the last two years of his life in New York, he made no essential changes in his style. And even in New York at the end of his life, when his compositions became more impressionistic and he momentarily returned to a color scheme of intermediate hues, he religiously preserved his right-angle theme and uncompromising non-objectivity.

In *Composition with Red, Blue, and Yellow,* the primary colors assert themselves with full brilliance. The ground is uniformly white; the thickness and quantity of black lines are minimized, being only sufficient to balance and counteract the activity of the three color rectangles. The asymmetric arrangement has an elementary simplicity, yet is essentially unrepeatable, since it results from a complex process of adjustments whose repetition produces mutation and renewal. The dynamics of Mondrian's art were his own restless curiosity and continual search for an equilibrated opposition of lines, planes, and colors that would promote the expression of a kind of free rhythm. As he put it, he sought a plastic rhythm that "manifests itself even more purely, more profoundly, more freely."

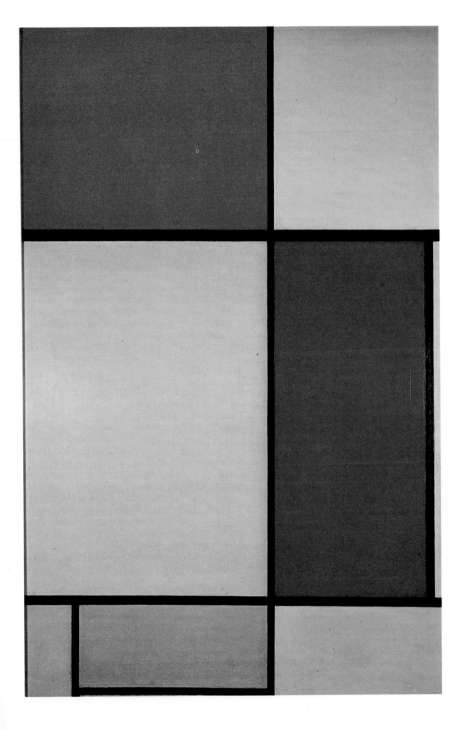

Marcel Duchamp (American, born France, 1887–1968)

THE BRIDE STRIPPED BARE BY HER BACHELORS, EVEN (THE LARGE GLASS) 1915–23

Oil, lead wire, foil, dust, and varnish on glass, 109¼ × 68⅛ in (277.5 × 175.6 cm)

Philadelphia Museum of Art · Bequest of Katherine S. Dreier

MARCEL DUCHAMP HAS become one of the legendary figures of twentieth-century art. He is recognized as a pioneer spirit of the New York Dada movement in the years between 1915 and 1920, even though he never officially declared himself a Dadaist. It was Duchamp who anticipated Dada's most fertile and challenging conceptions, including the whole complex of antiart ideas embodied in the "ready-made," which refuses to make elitist distinctions about the art object. *The Bride Stripped Bare by Her Bachelors, Even* is Duchamp's famous spoof on both romantic love and the machine, presented in diagrammatic form and accompanied by elaborate written notes of a speculative and philosophical nature, laced with irony and humor.

The painted construction is a windowlike and transparent object, made of two panes of double-thick glass, which symbolizes an amatory subject matter that had been evolving in Duchamp's paintings and objects of the preceding years. The work has become the object of a cult and spawned numerous conflicting interpretations, which range from its relationship to machine-art imagery to a symbolism of the occult and alchemical. Its most plausible meanings are still those elaborated by Breton in a well-known essay, which describes its lavish ingenuity as "a mechanistic . . . interpretation of . . . love." *The Large Glass* shows the bride mechanism metaphorically disrobing in its upper portion, as she both frustrates and attracts her suitor, setting off a series of visible reactions. The fact that the "love operation" (Duchamp's words) is not fulfilled seems clearly a metaphor of sublimation. As has so often been the case, celibacy is associated with intellect and with a creative aberration, in opposition to nature's cycle of sex and procreation.

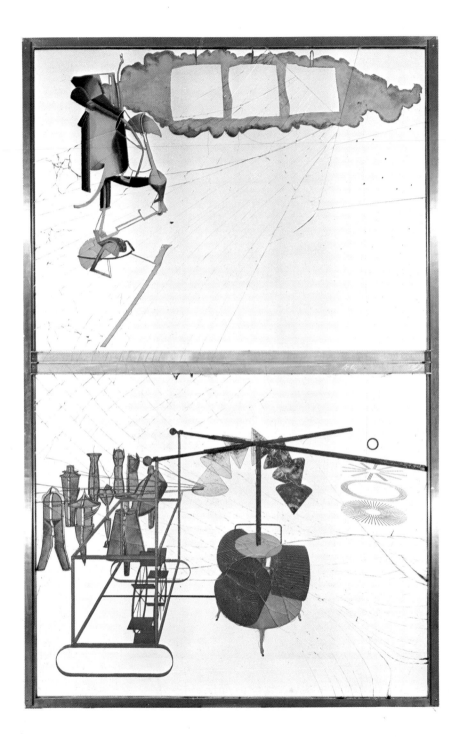

Francis Picabia *(French, 1879–1953)*

AMOROUS PARADE 1917

Oil on cardboard, 37¾ × 28¾ in (95.9 × 73 cm)

Morton Neumann Family Collection, Chicago

IN 1910, DUCHAMP MET and immediately began to influence Francis Picabia, a wealthy Parisian of Cuban and French descent who shared his taste for paradox, public jokes, and obfuscation. Picabia visited New York at the time of the Armory Show, where he exhibited a number of cubist-inspired paintings with enigmatic overtones. Two years later, much like Duchamp, he launched a shocking erotic-mechanical style. A typical creation, which made a visual pun on American innocence and machine worship, was *Young American Girl in a State of Nudity,* nothing more than a mechanical drawing of a spark plug with the brand name For-Ever. Picabia's machinist imagery in *Amorous Parade* exerted a direct impact on the so-called "precisionists," Charles Demuth, Charles Sheeler, and others. He also bore direct responsibility, no doubt, for America's most daring native Dada object, a miter box with a plumbing connection ironically entitled *God,* by Morton L. Schamberg. Picabia injected a proto-Dada spirit into Alfred Stieglitz's review *Camera Work,* and later into the gallery journal *291,* which affected the course of progessive American art for some time.

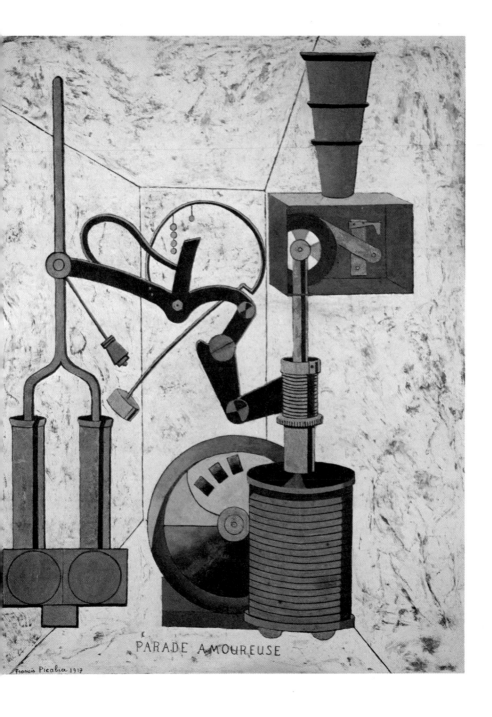

PARADE AMOUREUSE

Francis Picabia 1917

Kurt Schwitters (British, born Germany, 1887–1948)

MERZ PICTURE 25A: DAS STERNENBILD 1920

Montage, collage, and oil on cardboard, 41⅛ × 31 in (104.5 × 79 cm)

Kunstsammlung Nordrhein-Westfalen, Düsseldorf, Germany

ONE OF THE MOST HUMBLE yet poetic of the German Dadaists was Kurt Schwitters, who created trash pictures and constructions, *Merzbilder,* as he called them, which redeemed anonymous rubbish salvaged from the gutter in considered formal structures based on cubism. He first exhibited them at the Sturm Gallery in Berlin in 1917. By incorporating commonplace object fragments taken directly from life, Schwitters posed the question of antiart content, but in a manner different from Duchamp's. He also extended the material possibilities of artistic expression. And in a subtle, poetic way, he commented on contemporary materialism by collecting in structures of indubitable artistic quality the detritus of society. *Das Sternenbild* ("star picture"), with its large forms, rougher materials of wood slats and wire mesh, and bold geometry, is unusual for an artist typically associated with intimate scale and nuanced arrangements of torn papers, ticket stubs, and newsprint.

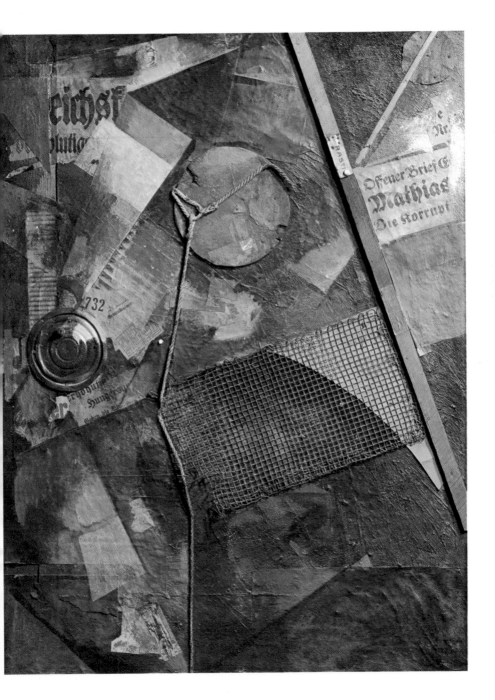

George Grosz *(American, born Germany, 1893–1959)*

ECLIPSE OF THE SUN 1926

Oil on canvas, 84 × 72 in (213.4 × 182.9 cm)

Collection of the Hecksher Museum, Huntington, New York

BETWEEN 1918 AND 1920, Dada spread from Zürich into Germany, creating not so much a consistent artistic style as a wave of liberating nihilism. In Berlin, Dada took its most overt political form, shaped by the sense of disillusionment of the desperately harsh postwar years. In Zürich, Tzara had insisted that Dada meant nothing, but in Germany, he said, Dada "went out and found an adversary." There it was linked with Communism and militantly involved itself in urgent political issues. Although the Berlin Dadaists produced little significant painting, their contribution to the development of collage and caricature was unique. George Grosz's bitter satires on the self-centered, decadent bourgeoisie and the bureaucrats of Berlin are grotesque, subhuman, and altogether memorable.

In the twenties Grosz's drawings and paintings became even more pungently realistic, powerful accusations of the corruption of the ruling classes—the military, the church, and swinish businessmen, all savagely caricatured. His intensified realism and ghastly subject matter found a counterpart in what became known as the "new objectivism," particularly in the work of Otto Dix and, briefly, in that of Max Beckmann.

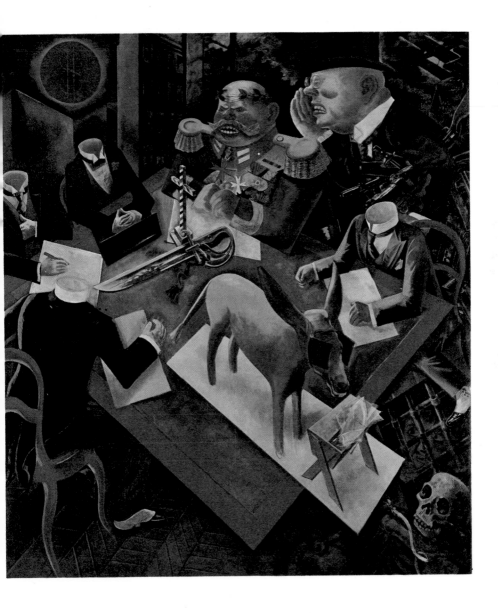

Max Beckmann (German, 1884–1950)

DEPARTURE 1932–33

Oil on canvas, triptych, center panel 84¾ × 45⅜ in (215.3 × 115.3 cm);
sides 84¾ × 39¼ in (215.3 × 99.7 cm) each

Collection, The Museum of Modern Art, New York

MAX BECKMANN IS A major figure among the German expressionists. Although he belonged to the generation of The Bridge painters, he did not take part in their organization. Before the war, however, Beckmann revealed an increasing tendency in his painting toward tragic themes. Beginning in the war years, and through the early 1920s, Beckmann's imagery was almost pathologically bitter and gruesome. In the 1930s, these moods gave way to a more hopeful and universal allegory, but even as he surrendered something of the pointedness and acuity of content, his painting means became more original and remained intensely expressive and personal.

In *Departure,* Beckmann's feverish colors and emphatic black outlines are applied to an uncompromising imagery of human violence and affliction that comments obliquely on the predatory impulses of German Nazism. The picture quite clearly symbolized the artist's own sense of relief on departing from Germany for the Netherlands and freedom, leaving a world of sadistic memories, symbolized by the tortured and trussed figures, to find a more serene life beckoning from beyond the brilliant blue sea.

Marc Chagall *(French, born Russia, 1887)*

I AND THE VILLAGE 1911

Oil on canvas, 75⅝ × 59⅝ in (192.1 × 151.4 cm)

Collection, The Museum of Modern Art, New York · Mrs. Simon Guggenheim Fund

CHAGALL WAS BORN IN Vitebsk, and after studying at an experimental school in St. Petersburg directed by the symbolist-influenced theater designer Léon Bakst, emigrated to Paris in 1910. There he entered the circle of Apollinaire and the cubists, meeting Amedeo Modigliani, Chaim Soutine, and Jules Pascin, who were later identified with him as members of the School of Paris. Chagall soon attained a reputation as a unique fantasist, comparable to almost no artist of his time except possibly Rousseau and de Chirico. Although the surrealists later generally showed little interest in Chagall, Breton did praise him, writing: "With Chagall alone . . . metaphor makes its triumphant entry into modern painting." Unlike the orthodox surrealists, however, Chagall's dreamlike imagery is gently lyrical rather than Freudian and disturbing.

In the delightful painting *I and the Village,* shifts and displacements of images take place as in the dream process, and the metamorphic principle dominates. The "dreamer" of the painting (with whose perceptions the artist makes us identify) is an improbable but appealing cow, which impresses the viewer both as icon and nature spirit. Chagall communicates a highly individual poetry, but he also concerns himself with the abstract dynamics of the painting process.

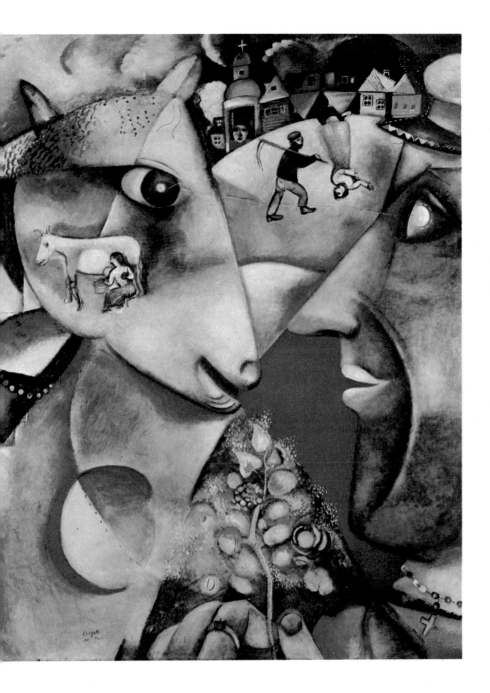

Chaim Soutine *(French, born Lithuania, 1893–1943)*

PAGE BOY AT MAXIM'S 1927

Oil on canvas, 51 × 26 in (129.5 × 66 cm)

Albright-Knox Art Gallery, Buffalo, New York · Edmund Hayes Fund

BORN IN A LITTLE Russian village near Minsk, Chaim Soutine was one of eleven children in a wretchedly poor Jewish family. Childhood poverty, emotional insecurity, persecution under the Tzar, and then escape into freedom formed the pattern of his life. He came to Paris in 1913 and entered a new and more congenial atmosphere, where he was no longer ostracized for his ethnic background, and where his talents guaranteed him status. Soutine was one of the many artists from Eastern Europe who uprooted themselves and took up a new life in the cosmopolitan art capital, contributing richly to the culture of their time.

Page Boy at Maxim's is one of a series of paintings of figures in sacerdotal garments, of page boys, and of other studies of costumes whose glamor appealed to Soutine's lapidary eye. In great streaks of fat, shining pigment the artist has set down an impression of remarkable freshness and vividness in a single, dramatic phrase. The free, elliptical shorthand and the compactness of the statement give the painting its modern character, even though the artist's idiom is more traditional than most in his time, recalling artists as diverse as El Greco, Rembrandt, and Courbet. Also modern is the emphatic vitality and almost independent aesthetic function of the pigment, apart from representational aims. The pure, disinterested paint material has such an assertive life of its own that it threatens the coherence of the subject matter.

Giorgio de Chirico (Italian, born Greece, 1888–1978)

THE MELANCHOLY AND MYSTERY OF A STREET 1914

Oil on canvas, 34¼ × 28⅛ in (87 × 71.4 cm)

Private collection

THE ARTIST OF FANTASY destined to play the most decisive role in the development of later surrealist painting was the Italian Giorgio de Chirico. Coming to Paris from Italy in 1911, he made contact with Picasso and the ubiquitous and influential Apollinaire. Not only did de Chirico create an authentic, troubling dream imagery of great power and intensity for the first time in the century, but he also managed to capture the spirit of the age, to convey, in André Breton's words, its "irremediable anxiety."

De Chirico's paintings freeze his reality into a trancelike immobility amid a scenario of improbable vistas, perspectives with conflicting vanishing points, and dramatically heightened contrasts of deep shadow and intense light. *The Melancholy and Mystery of a Street* creates a strangely ominous atmosphere, where time has ceased to exist and curious events transpire: Unseen public statues cast long shadows; a van with open door lurks in the shadows; a phantom child rolls a hoop; in the motionless air, distant pennants flutter in a hidden breeze. The viewer has the sense of being imprisoned in a nightmare. Everything has too bright and disturbing a clarity, creating an unnatural luminosity from which we crave release.

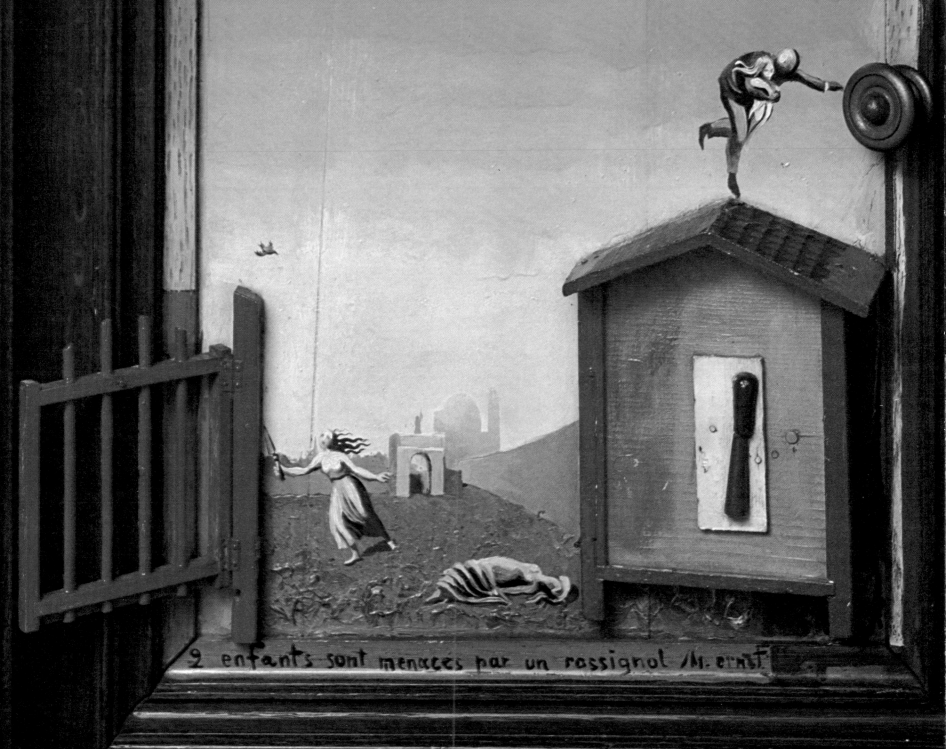

2 enfants sont menacés par un rossignol /M. ernst

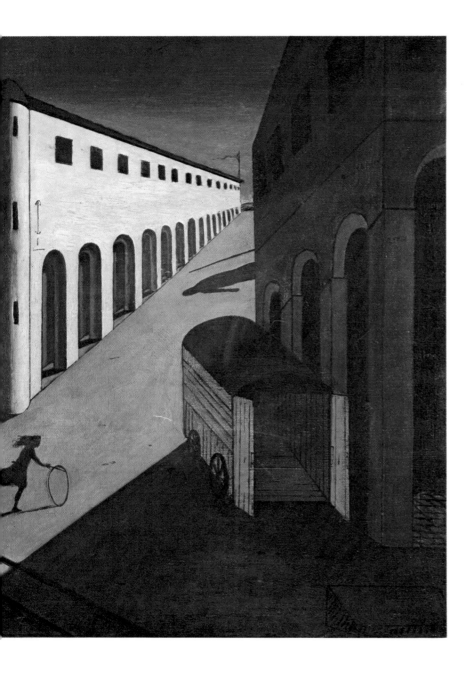

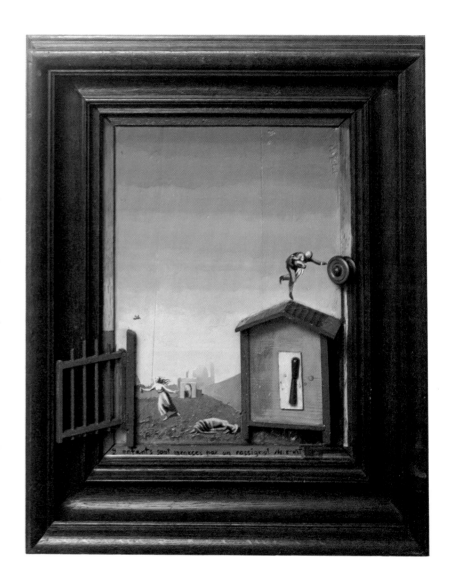

Max Ernst *(French, born Germany, 1891–1976)*

TWO CHILDREN ARE THREATENED BY A NIGHTINGALE 1924

Oil on wood with wood construction, 27½ × 22½ × 4½ in deep (69.9 × 57.2 × 10.4 cm)

Collection, The Museum of Modern Art, New York

INFLUENCED BY DE CHIRICO's deep space and trancelike reverie, Max Ernst began to make illusionistic paintings in the early twenties which transposed some of the monstrous imagery already hinted at in his Dada collages into more complex visual symbols. De Chirico accounts for such enigmatic, if aggressive, images as *The Elephant Celebes* and *Oedipus Rex.* In the painted construction *Two Children Are Threatened by a Nightingale,* made the year surrealism was officially launched by André Breton in Paris, de Chirico's ominous dream world has escalated to a precipitous sense of nightmare and panic.

The terror of Ernst's children is perhaps reminiscent of Gothic tales of the late eighteenth century, or earlier German fairy tales. Much like Ernst's collages, these realistic dream images are based on incongruous juxtapositions of strange material objects and painted human figures set in a picture-postcard space. The painting supports his conception of "the culture of systematic displacement" and of alienation and disorientation, which Ernst defined as the inherent technique of his collages. Ernst's first paintings and constructions in illusionistic form of the early 1920s dramatize the growing differences between Dadaist protest and the surrealist affirmation of a new dream reality. They represent the true beginnings of surrealist painting even before Breton had officially codified the movement in *The First Surrealist Manifesto.*

André Masson *(French, born 1896)*

IN THE FOREST 1944

Tempera, oil, and sand, 22 × 15 in (55.9 × 38.1 cm)

Albright-Knox Art Gallery, Buffalo, New York · Room of Contemporary Art Fund

In HIS FIRST MANIFESTO, the poet André Breton defined surrealism as "psychic automatism," by which he meant the free and uncensored association of image and idea. Literature of the period was full of examples of the uninhibited and incongruous juxtapositions of images, but few examples of automatism existed in painting. The primary innovator in this direction of automatic surrealism was André Masson. In fact, his example became extremely influential, affecting artists as different as Miró and Jackson Pollock. His form of automatism was a kind of abstract calligraphy, where the rhythm of swift lines or cursive brushmarks generated images of violence and dramatic encounters of form.

Masson's paintings are remarkable both for inventing visual equivalents of automatism and for plausibly creating a magical and autonomous world, with hints of anatomical and mythic imagery. Some of his most effective ensembles of metamorphic hybrids were made in a medium of tube pigment mixed with sand, which was randomly applied to areas of spilled glue. The animal violence of works in this style, such as *In the Forest,* became powerful metaphors for human passion.

Joan Miró (Spanish, born 1893)

PERSON THROWING A STONE AT A BIRD 1926

Oil on canvas, 29 × 36¼ in (73.7 × 92.1 cm)

Collection, The Museum of Modern Art, New York

UNDER THE INFLUENCE OF André Masson and surrealism, Miró began around 1926 to introduce ideographs, a freely moving, cursive calligraphy, and fantastic content into his complex art. Unlike the more orthodox surrealists such as Dali and Magritte, he never embraced the more picturesque tendencies of the movement, its trompe-l'oeil techniques of illustration and incongruous association. He worked instead within the formal side of surrealism, mainly adopting its automatism and hyperactive principle of analogy. He did, however, share with the illusionistic surrealists a belief in "the omnipotence of the dream."

Persons in dreams or under the influence of drugs have often experienced a sense of infinite extension. One way to express this disturbing state of mind is, as Miró has done, by creating a figure who drags a monumentally large foot and whose head is disproportionately small and remote from this lower appendage. To show such a figure only in profile compresses symbolic content and removes the situation from rules of logic, one of the central aims of surrealism. In this strange, hypnotic dream world the artist suddenly energizes the scene with a sharp accent of red on the bird and the white flash of a stone in flight. Movement and activity are suggested by the dotted trajectory line in an otherwise sedative landscape.

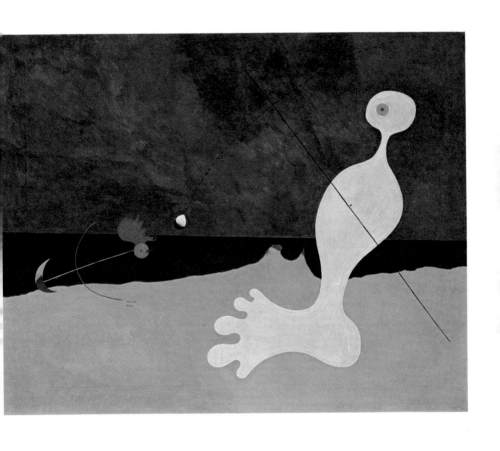

Yves Tanguy *(American, born France, 1900–1955)*

INDEFINITE DIVISIBILITY 1942

Oil on canvas, 40 × 35 in (101.6 × 78.9 cm)

Albright-Knox Art Gallery, Buffalo, New York · Room of Contemporary Art Fund

YVES TANGUY's surrealist illusionism created a precious and magical submarine dream world, inhabited by barely living creatures rendered in three-dimensional biomorphic form. Tanguy began to paint his tight, meticulously exact detail even before Dali, and his manner reached maturity in 1927. *Indefinite Divisibility* represents a visionary re-creation of some desolate desert plateau or ocean floor, where natural properties are confused and mingled in their liquid, gaseous, and crystalline states. His paintings have the ambiguous perspectives and horizons and the long vistas of de Chirico's, as well as the contradictory ambience of air, water, and light that makes Ernst's early surrealist paintings so confusing in locale and personae.

For Breton, Tanguy's paintings seemed to realize his own dream, expressed in the book *Clair de Terre*, of reconstituting the banal earth as a new habitat. He wrote that Tanguy had the ability "to yield to us images of the unknown as concrete as those which we pass around of the known," and added that his paintings provided "the first nonlegendary glimpse of the considerable area of the mental world which exists at the Genesis."

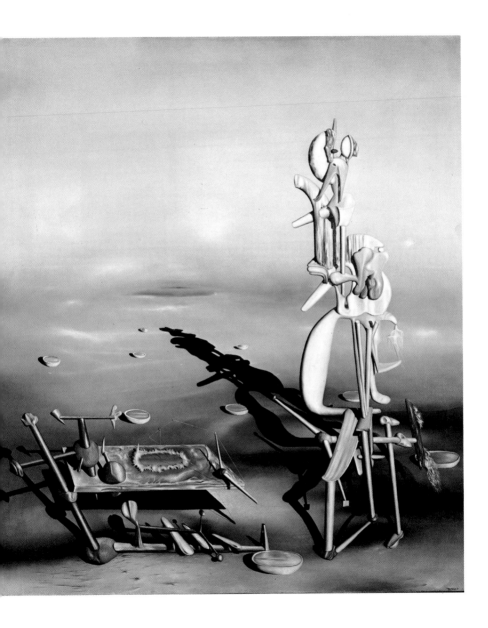

René Magritte (Belgian, 1898–1967)

PROMENADES OF EUCLID 1955

Oil on canvas, 63¾ × 51¼ in (161.9 × 130.2 cm)

The Minneapolis Institute of Arts, Minnesota · William H. Dunwoody Fund

THE BELGIAN SURREALIST René Magritte frequented the Breton circle in Paris in 1927–30 and then returned to Brussels, where he painted his haunting visual conundrums in a scrupulously exact and deliberately banal technique. Among the illusionistic surrealists Magritte bears the most relevance to contemporary art, because his dissociated images and contrasts of objects and unrelated words pose questions of meaning and relationship between painted and real objects. They present the problem of creating new forms of identity as a part of the creative process.

One of his best-known visual riddles is *Promenades of Euclid*, with its easel and transparent canvas, for it manages to thoroughly confound depicted art and natural landscape. The contradiction between the painted illusion and the actual scene questions the nature of reality, but the real magic of the work lies in the threatening sense one has that neither nature nor subjective vision can be anything more than a hallucination or a fabrication. The nature of reality and our grasp of it seem to be matters over which we no longer exert effective power.

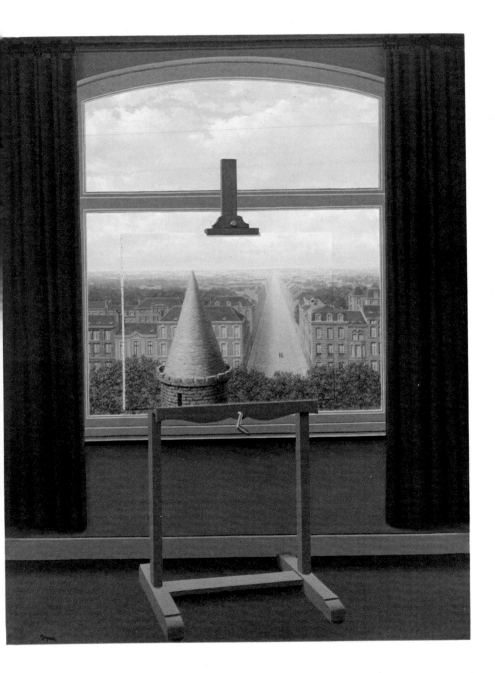

Alberto Giacometti (Swiss, 1901–1966)

DIEGO 1953

Oil on canvas, 39½ × 31¾ in (100.3 × 80.6 cm)

The Solomon R. Guggenheim Museum, New York

AFTER WORLD WAR II, in an atmosphere of despair and self-doubt, Alberto Giacometti's painting as well as his sculpture underwent a radical transformation. In place of his familiar repertory of enigmatic, often brutal surrealist objects, he discovered a new, denuded, hesitant impressionist style, defining emaciated human figures in a devouring spatial void. Sometimes his figures were reduced to a nearly invisible network of inchoate lines, no bigger than a pin; at other times, they were elongated and enlarged to monumental proportions. He himself described the works, defining his own mood, in terms of "petrified incompletion." The somberness of his experiments was augmented by his restriction to grisaille, at best enlivened by touches of neutralized color. The subject of this painting, Giacometti's brother Diego, was one of the few models with sufficient patience to suffer through the agony of the interminable portrait sittings required to satisfy the artist.

When Giacometti showed his new sculptures and paintings at the Pierre Matisse Gallery in New York in 1948, Jean-Paul Sartre fittingly wrote the catalogue introduction. His eloquent homage can be taken as an indication of the sculptor's problematic and existential content. Giacometti tried to unify individual human forms with a space that eroded their recognizable humanity, and he covered his figures, in Sartre's challenging phrase, with "the dust of space." The artist thus symbolically expressed the profound sense of solitude and anxiety of an uprooted postwar humanity, bereft of traditional institutional supports or consolations. In *Diego*, the rough and tenuous definition, jumbled surfaces, and blank, expressionless face in telescopic scale give the diminutive figure an air of alienation both from its own environment and from the observer.

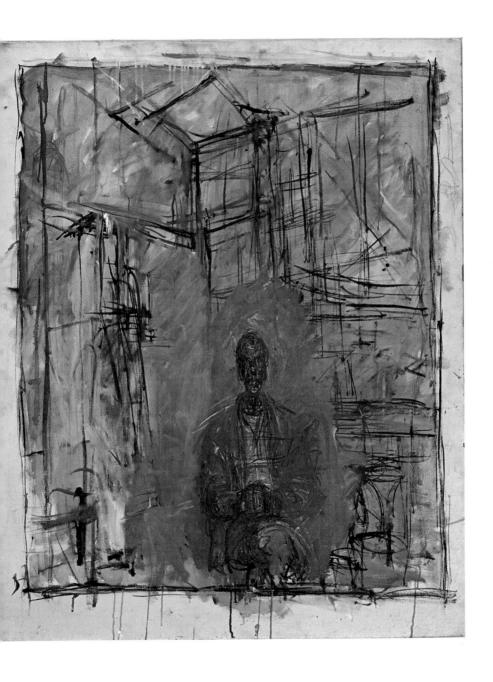

Jean Dubuffet (French, born 1901)

PROMENADES EN TOURAINE 1977

Acrylic and paper collage on canvas, 82 ½ × 98 in (209.6 × 245.9 cm)

Courtesy the Pace Gallery, New York

JEAN DUBUFFET'S ART combines the human comedy, primitivism, and high sophistication. In his first rather macabre and primitivist postwar portraiture of his friends in High Bohemia, he captured the feelings of solitude and anxiety that dominated a period when existentialism became such a popular philosophy. As his art matured, some of the caricatural elements of his early portraits gave way to more studied formal concerns of surface texture, paint manipulation, scale, and other abstract considerations which linked his work with the best nonobjective expressions of his epoch. In the early 1960s, Dubuffet initiated a new and strongly ornamental painting series on which he conferred the deliberately meaningless, if suggestive, title of *L'Hourloupe* (in the French, the words *wolf* and *scream* both emerge from its phonetic rendering).

Dubuffet continued to paint the *L'Hourloupe* series until the mid-seventies, when his compulsive and tightly ornamental patterning gave way to a looser style and a more relaxed human comedy. His *Scènes Champêtres* of recent years contain discernible vegetation and landscape elements as well as the ubiquitous ideographic human figures, as befits their pastoral themes. Some of the idiosyncratic doodles of his *L'Hourloupe* style persist and remind us of the bizarre flourishes of pathological art which Dubuffet has systematically collected, published, and exhibited for many years under the rubric of *art brut*. His current *Scènes Champêtres* have a deceiving cheerfulness in their elementary design and bright, nursery colors. Upon closer inspection, however, the jumbled maps and emphatic black outlines reveal faces, human or animal anatomies, fantastic trees and rocks, all pervaded by a disturbing sense of estrangement and the gratuitous spirit of the grotesque.

88

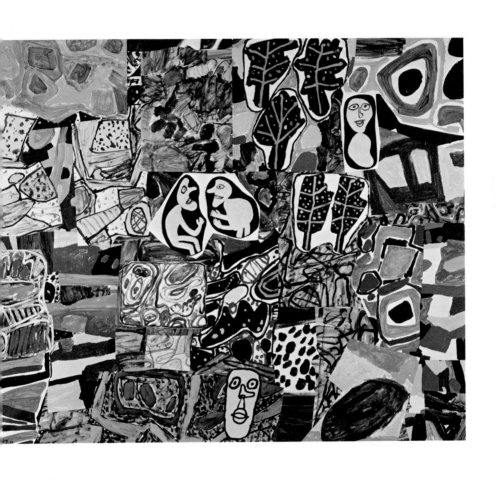

Francis Bacon (British, born 1909)

STUDY NUMBER 6 AFTER VELAZQUEZ'S PORTRAIT OF POPE INNOCENT X, 1953

Oil type on lines, 59⅞ × 46 in (152.1 × 116.8 cm)

The Minneapolis Institute of Arts, Minnesota · Miscellaneous Works of Art Fund

Eɪɢʜᴛ ʏᴇᴀʀs ʏᴏᴜɴɢᴇʀ than Dubuffet, Francis Bacon was certainly the only British figurative painter to rank with the most distinguished artists of the postwar period. He has dealt with the same existential theme of isolation and anguish that preoccupied so many, pushing it to an even further point of psychic distress and hysteria than did Dubuffet and Giacometti. His preoccupation with terror was both melodramatic and psychological in impact, and it often seemed to be drained off directly from catastrophic journalism and visual accounts of the holocaust of World War II. With his sense of surrealist menace and an imagery blurred as if in motion, Bacon stated the case for postwar European despair with a vehemence and originality that earned him a special place among contemporary Cassandras. His first important painting series were his variations on Velazquez's *Portrait of Pope Innocent X,* beginning around 1950. These vivid and powerful inventions transformed the crafty and smug prince of the church into a monstrously depraved image. Influenced by early film classics as well as tabloid journalism, Bacon synthesized photographic images of gunmen, Muybridge's motion studies, Eisenstein's *Battleship Potemkin,* and direct allusions to news photographs of Hitler and his barbarian lieutenants to create a half-real, half-fantastic world, a chamber of public horrors and private nightmares.

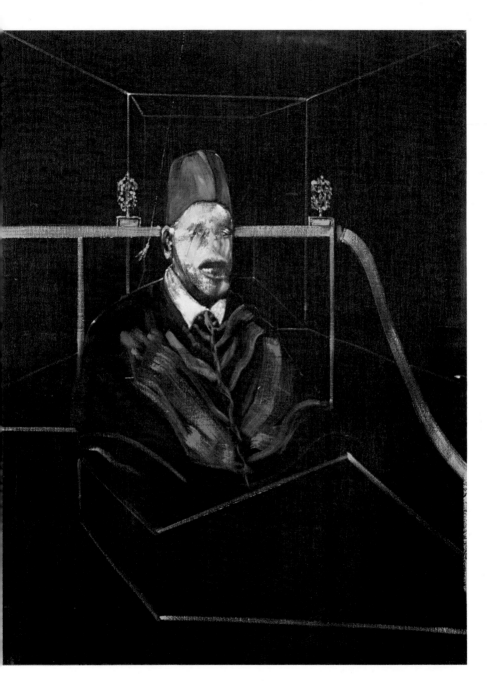

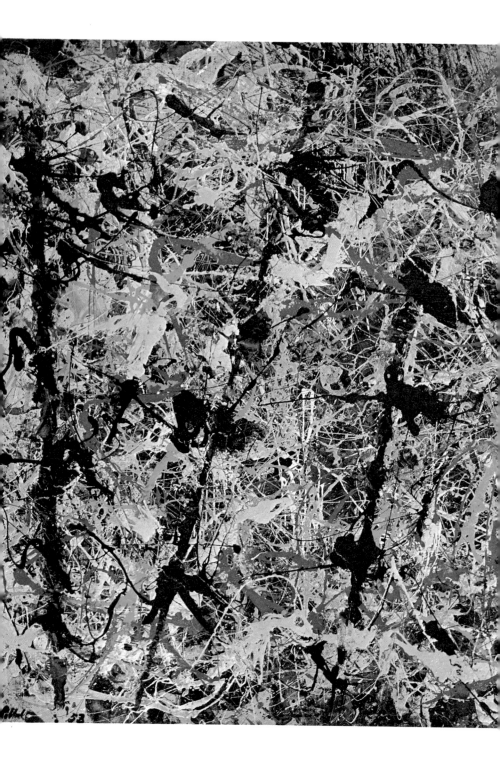

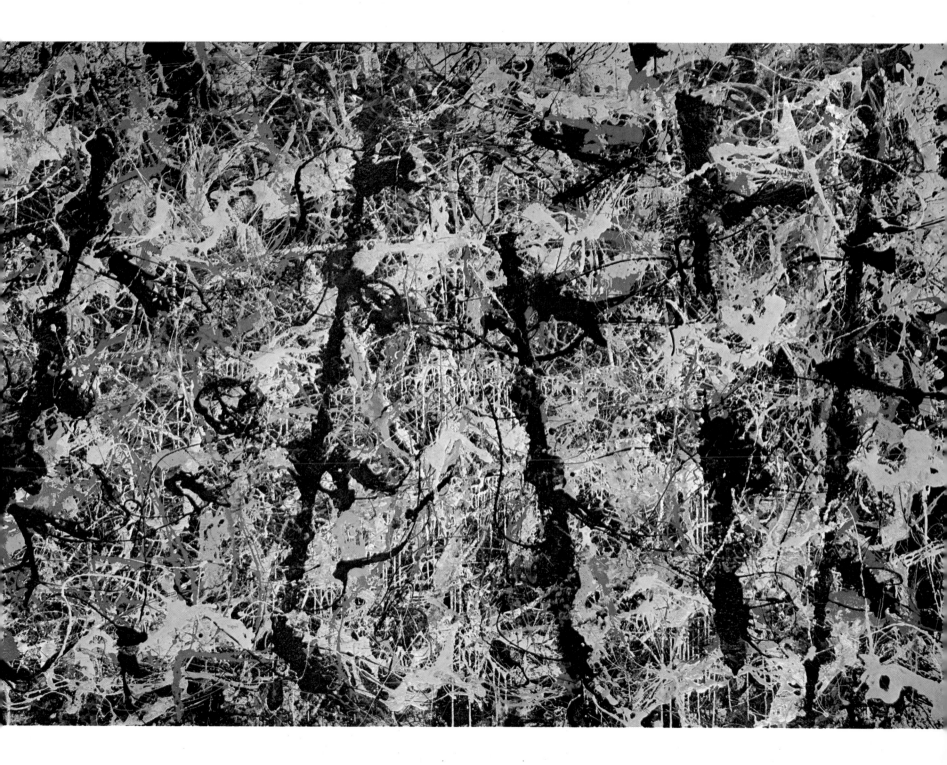

Jackson Pollock *(American, 1912–1956)*

BLUE POLES 1952

Enamel, aluminum paint, and glass on canvas, 83 × 192 in (210.8 × 487.6 cm)

Collection: Australian National Gallery, Canberra, Australia

JACKSON POLLOCK'S FIRST New York one-man show in 1943 at Peggy Guggenheim's gallery, Art of This Century, ushered in a new era in American avant-garde painting, which later was to be called "abstract expressionism" or, alternately, action painting. By 1947, Pollock had eliminated his allusions to recognizable imagery, as he began to pour and spray paint freely on the canvas in repeated rhythmic gestures. Thanks to his unorthodox technique of dripping and pouring paint and to the *Life* magazine camera, which conveniently trapped him in the dramatic seizure of his painting ritual, he came to epitomize the popular image of the modern and contemporary artist as an inspired madman. By the seventies, however, Pollock was also an acknowledged classic in American art; his painting *Blue Poles* managed to fetch the highest price ever in twentieth-century American art when it was sold from a private New York collection to the Australian national museum for a reported sum of two million dollars.

Pollock employed the surrealist technique of automatism— without its fantastic content—to get his picture started. The increasing speed of execution and spontaneity of his paint application led to the "all-over" compositional form, consisting of an unending network of lines folding in on each other, creating the impression of a spatial activity in continuous motion. The furious paint drips and streaks intensify the feeling of dynamism and even vertigo, but the lancelike diagonal "poles" in cobalt blue lend structural stability to the painting. The viewer experiences the excited paint handling and a sense of heroic pictorial scale that draws him into the work in such a way that he identifies directly with the "act" of painting itself. In recent years, the focus in criticism and appreciation have shifted, however, from Pollock's expressionist energies and gestural action to the environment scale and optical pulsation of his "all-over" painting fields, which manage to erase boundaries between the realm of the art object and the space the viewer occupies.

Willem de Kooning *(American, born the Netherlands, 1904)*

WOMAN, SAG HARBOR 1964

Oil on wood, 80 × 36 in (203.2 × 91.4 cm)

Hirshhorn Museum and Sculpture Garden · Smithsonian Institution, Washington, D.C.

FOR THE PAST DECADE and a half, Willem de Kooning's celebrated "woman" image, once known for its grotesquerie and painterly violence, has become more serene. Today it has metamorphosed into a composite form of woman-landscape suggesting the watery vistas of Long Island, where the artist now lives and paints. The old bit of aggression is absent from this new "woman," despite her continued grimace; the mood of the painting has, in fact, become clearly tender and pastoral. We can identify the dismembered human figure with the shifting patterns of light and dark, and with the openness of nature itself.

De Kooning moved his studio from downtown New York City to the countryside in 1961. The trapped energies of his earlier claustrophobic spaces often suggested the city environment even when he painted his half-grinning, half-grimacing female cult image. That famous visage and contorted anatomy—his pictorial formula for paroxysm and pain—have now given way to a more genial kind of improvisation. The mellow, autumnal colors of his flesh tones and the cool areas in the foreground, as well as the sense of plunging vista resembling a view down a long reach of land and water, all contribute to a new sense of stability in his painting. The artist's sense of personal crisis, once linked to postwar moods of despair and to the existentialist philosophy of alienation, is dissolved in the flat distances, brilliant light, and shifting scenic attractions of a benevolent marine environment.

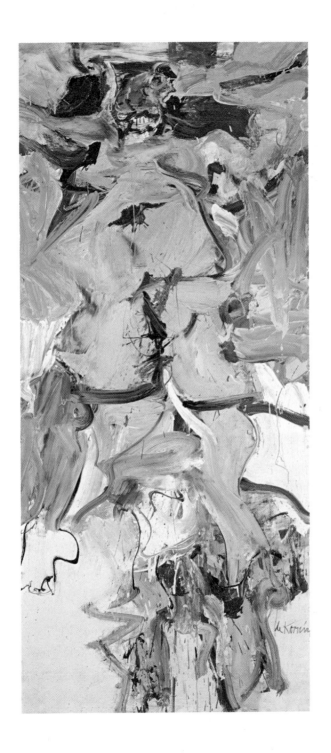

Georgia O'Keeffe (American, born 1887)

YELLOW CACTUS FLOWERS 1929

Oil on canvas, 29¾ × 41½ in (75.6 × 105.4 cm)

Collection: The Fort Worth Art Museum, Fort Worth, Texas
Gift of William E. Scott Foundation

GEORGIA O'KEEFFE IS perhaps America's most distinguished woman artist, and a pioneer of our first modernist avant garde. Alfred Stieglitz, who later became her husband, organized her first individual exhibition at Gallery 291 in 1917. Influenced by Stieglitz's "Equivalents," a photographic series of cloud and landscape fragments, O'Keeffe began to isolate and enlarge her natural imagery in the twenties, until individual details were magnified to a point where they ceased to be recognizable as representational objects. In extreme enlargement, *Yellow Cactus Flowers* takes on the character of an abstract and symbolic emblem—the universe in microcosm. As O'Keeffe's art developed, she abandoned her soft, amorphous forms for a more severe stylistic phase of crisp precisionist edges and austere paint surfaces. There is an element of unconscious puritanism even in her soft flower paintings, with their hints of sensual abandon. The American sense of fact adds rigor to her languid cactus flowers, however, suggesting the influence of the meticulous, sharp-focus photography of Paul Strand and Edward Weston, who were close to the Stieglitz group. Whatever her themes or treatment, O'Keeffe manages to invest her subject matter with a unique combination of formal precision and romantic mystery.

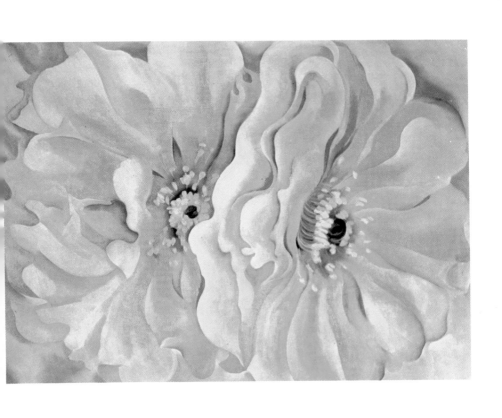

Mark Rothko *(American, born Latvia, 1903–1970)*

UNTITLED 1961

Oil on canvas, 105 × 83 in (266.7 × 210.8 cm)

Collection, Arnold and Milly Glimcher, New York

WITH CLYFFORD STILL and Barnett Newman, Mark Rothko created large color-field paintings in the fifties as a formal alternative to the gestural abstraction of the action painters. Their large undetailed surfaces and burning colors were intended to subdue the spectator's ego and create a sense of tranquil awe, asserting the boundlessness and mystery of being, in keeping with Edmund Burke's concept of the sublime in art.

By the sixties Rothko had moved towards a more daring experiment with closely-valued colors, which approached subliminal chromatic effects and at times made even visibility problematic. In this he seemed to be moving along a parallel track with Ad Reinhardt, who had begun in 1954 to make all-black monochromatic paintings, though over a supporting cruciform geometric figure. Rothko's mastery of both color nuance and formal structure reveals itself in this untitled painting from 1961. Two irregular rectangles, with fuzzy perimeters much like a rain cloud at the moment of precipitation, are set on a red ground. Blue-black in the upper tier and maroon below, the configuration achieves a formal stability even as the resonant color-space evokes a powerful emotional response.

Despite its nearly square format, unrelieved frontality, and a relatively bare and inert surface, Rothko's painting achieves a majestic monumentality. Heroic scale was important to him, both in formal and human terms. He stated in print that he wished his paintings to be accessible as an intimate experience even as the observer sensed their physical and moral grandeur.

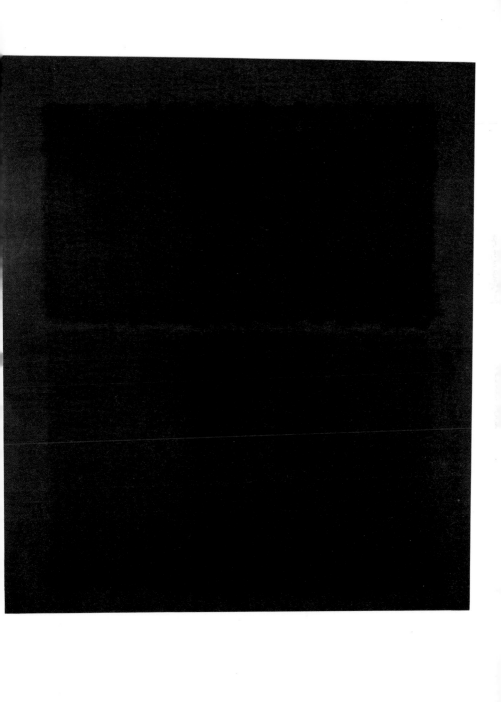

Victor Vasarely (French, born Hungary, 1908)

VONAL—SZS 1968

Oil on canvas, 63 × 63 in (160 × 160 cm)

Collection of the artist, Annet-sur-Marne, France

VICTOR VASARELY WAS the leader of a group of abstract artists in the postwar period who created the movement of op art, so called because it explored a new perceptual activism in the viewer's experience of the painting and sculpture object. Although his debt to the classical constructivists is clear in his geometric forms, his optical dynamic subverts the closed formal order of the old purist generation. A sometimes subtle, but more often strident optical pulsation assaults the eye in nearly intolerable color intensities and oppositions, which create a fluctuating pictorial surface.

Vasarely's dominant interest in affirming the relationship of art and technology through his optical experiments directly stimulated the formation in 1960 of the influential GRAV group (Groupe de Recherche d'Art Visuel). He was also a leader in creating the idea of "multiples," the inexpensive fabricated art objects or prints which, through the advantages of new reproduction technology and large-volume sales, were able to reach a larger audience than ever before. Vasarely envisioned an art more accessible to popular taste, whereby the ideas of rarity and of the masterpiece could be dissociated from the art object. "The masterpiece," he wrote, "is no longer the concentration of all the qualities into *one* final object, but the creation of a *point-of-departure prototype*, having the specific qualities, perfectible in progressive numbers."

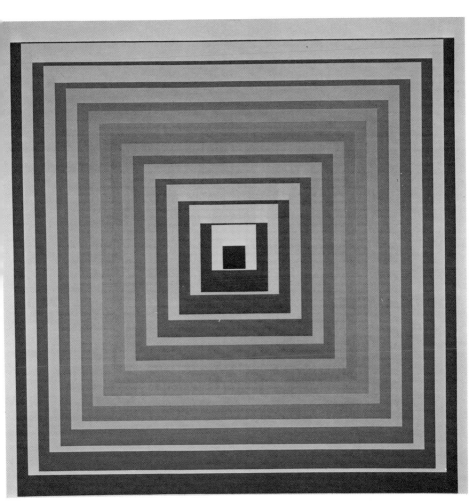

Robert Rauschenberg (American, born 1925)

RETROACTIVE I 1964

Oil and silkscreen ink on canvas, 84 × 60 in (213.4 × 152.4 cm)

Wadsworth Atheneum, Hartford, Connecticut

ROBERT RAUSCHENBERG'S JUMBLED ensemble of fragmentary images and pictorial gestures creates a sense of rapid metamorphosis prophetic of the first investigations in the early sixties of environmental slide shows and intermedia experiments which began to radically transform art values at that time. New spatial and communication ideas infiltrated art through the process-oriented media of films, television, exhibitions, "happenings," and other events, opening up unexpected creative opportunities and swiftly changing the forms of traditional painting. Rauschenberg was one of the first artists to test the new technical and aesthetic frontiers, now so familiar, in response to the communications dynamism of the electronic age.

In the sixties Rauschenberg began to silkscreen his overlaid images on canvas, using the visages of such well-known public personalities as President Kennedy, scenes from sports events and topical journalism, or dramatic news photos of fires and accidents. The blurring and manipulation of images give his composition the quality of aesthetic distance, even when his human subjects are immediately recognizable. Despite the appearance of visual reportage and his keen feeling for the actual moment, he manages to establish an atmosphere of calm in the unresolved actions he portrays, such as the descending parachutist. He never permits narrative interest to upset his formal control. His deliberately untidy contours and runny, smeared paint remind us that his work bridges the gap between action painting and pop art.

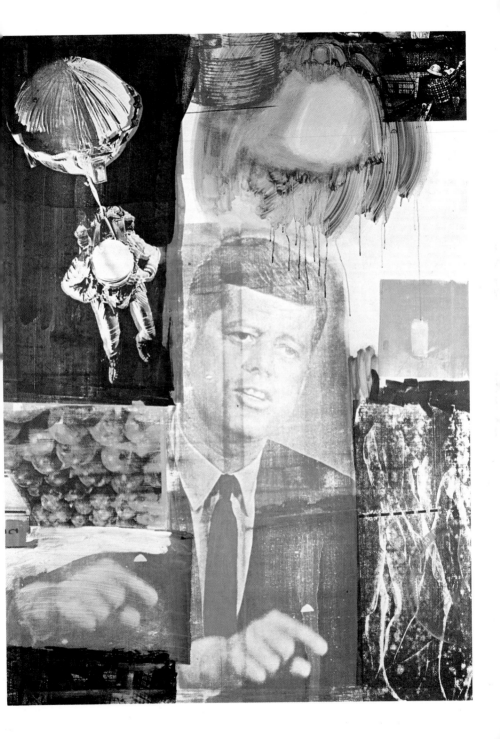

Jasper Johns (American, born 1930)

PASSAGE II 1966

Oil on canvas with objects, 59¾ × 62½ in (151.8 × 158.8 cm)

Private collection, New York

JASPER JOHNS'S HISTORICAL contribution depends on the far-reaching innovations he made in the paintings of flags and targets, first exhibited in 1957, and the subsequent maps, number series, rule and circle devices, and other motifs which together created radical new forms of representation in American art. Johns transformed the familiar stars-and-stripes image into an abstract painterly field obviously linked to abstract expressionism, but functioning in a new way as an abstract visual cipher divorced from its functional meanings. He thus managed to combine representation and abstraction in a fresh synthesis, a problem which de Kooning, Pollock, and the other abstract expressionists could not resolve.

Passage II creates a constant interplay between flatness and depth and between free brushwork and stenciled lettering or objects attached to the canvas. The plaster knees, modeled from the anatomy of a well-known art critic, allude to personal friendship, and the neon lettering spelling out color names refers to the palette. Like the American flag image and other pictorial clichés, Johns's earlier sculptural objects—such as the bronze casts of beer cans and the coffee can stuffed with studio brushes—opened the way for the development of American pop art. In contrast to Duchamp, who placed the ready-made object in the realm of art, Johns has reversed the process and transformed actual objects into elegantly crafted replicas set in a painting field.

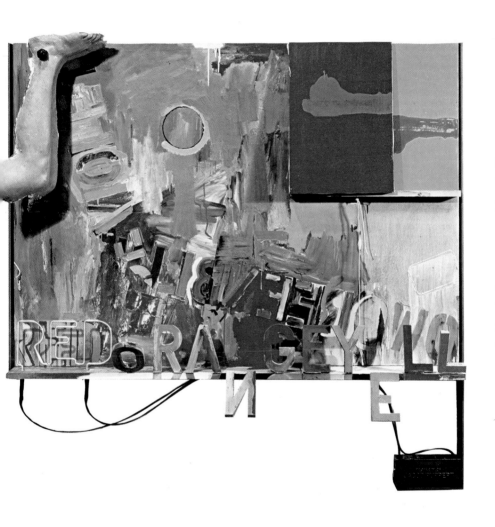

Andy Warhol (American, born 1930)

ELECTRIC CHAIR: FOUR CANVASES 1964

Silkscreen and Liquitex, 45¼ × 57½ in (114.9 × 146.1 cm)

Private collection, New York

DESPITE THE CLEAR IMPERSONALITY and impassivity of his silkscreened "disasters," a subtle social commentary can be found in Andy Warhol's adaptation of our ubiquitous news media imagery. The artist has stated, "When you see a gruesome picture over and over again, it doesn't really have any effect." Warhol's detached aestheticism, his attitude as the uncommitted observer, thwarts any sense of emotional identification even with the savage American custom (about to be revived, apparently) of executing criminals in the electric chair. Despite his own emotional blankness and the photos' mechanical method of image registration, Warhol consciously operates in the area of public myth. He can even be viewed as a modern-day history painter, sensitive to the important issues and personalities of his time, and especially to those catastrophic or sensational events which feed the news media's insatiable appetite for human drama.

Warhol's approach to contemporary imagery is to use his canvas much as he does his film, as a random and continuous medium. An important part of his subject matter is the reproduction process itself. The coarse scrim of silkscreened halftone dots gives his images a visual roughness that identifies them as media products. Since his own presentation is straightforward, even literal, the viewer is thrown back onto the surface marks, blotchy paint, and imperfect color registration, which enliven and artistically assimilate his disturbing subject matter.

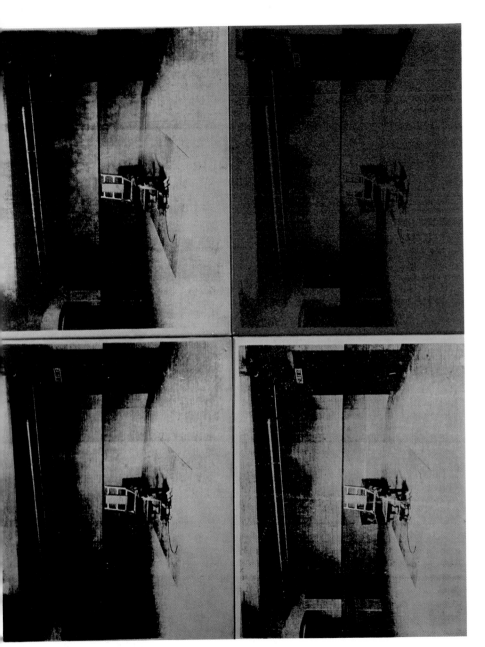

Frank Stella *(American, born 1936)*

SINJERLI VARIATION I 1968

Fluorescent acrylic on canvas, diameter 120 in (304.8 cm)

Private collection, New York

Frank Stella is one of the most influential and original artists in the new generation of abstract painters in America born around 1935. Beginning with his black pinstripe paintings in 1960, his anti-expressionist bias and a far more literal approach to the abstract painting as an object rather than an illusionistic pictorial field helped force a fundamental change in artistic outlook. His subsequent shaped canvases, permutations of V's, parallelograms, rhomboids, and hexagons, and the inexhaustible, colorful arcs of his lengthy "Protractor" series in the late sixties de-emphasized traditional forms of composition. Stella helped generate new forms of three-dimensional construction perhaps even more than changes in pictorial methods.

Sinjerli Variation I belongs to the Protractor series, named after the engineering model for constructing and measuring angles and curves. Begun in 1967, the group of curvilinear, geometric structures was planned in three different formats as "interlaces," "rainbows," and "fans." The word "Sinjerli" is taken from an ancient circular city of Asia Minor—Islamic art and related Hiberno-Saxon illumination have long attracted Stella, and in the early sixties he traveled in the Near East. In addition to his Celtic/Islamic interests, one finds the influence of Art Deco, with its modern decorative geometries, and the color orchestrations of Delaunay's Orphic cubism. The tightly latticed forms play against fluorescent water-based colors that glow with a disembodied brilliance, creating a monumental canvas of unique visual power. One of America's most inventive and versatile abstract artists, Stella achieved perhaps his most seductive decorative works on a heroic scale with the Protractor series.

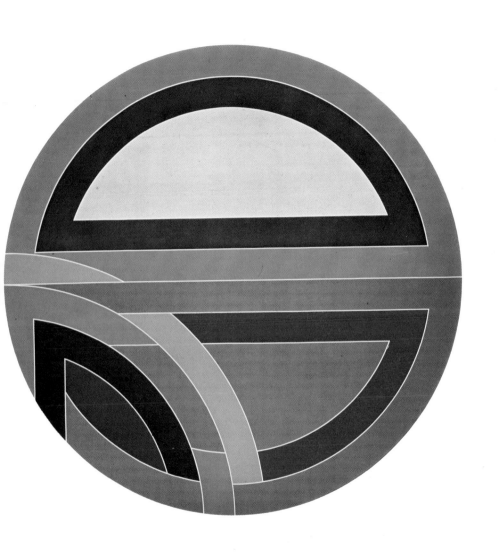

Amedeo Modigliani *(Italian, 1884–1920)*

WOMAN WITH A NECKLACE 1917

Oil on canvas, 35¾ × 23½ in (90.8 × 59.7 cm)

The Art Institute of Chicago · Mr. and Mrs. Charles H. Worcester Collection

IN A PERIOD NOTABLE for its originals, Modigliani was one of the most extravagantly individualistic members of Paris's Bohemia. He came to France from Italy in 1906 and very soon acquired a formidable reputation for his flamboyant lifestyle. After almost methodically destroying his delicate health by excessive drinking and drugs, he died of tuberculosis at the age of thirty-six.

In his painting Modigliani was a traditionalist rather than an innovator, and he perhaps owes more to post-impressionism and to his Italian heritage than to contemporary idioms. *Woman with a Necklace* has the linear grace and elegant stylization of a Botticelli. The model does not quite belong to the genre of the ugly or the femme fatale of much twentieth-century portraiture, nor is she overly idealized. Here an image of young womanhood has been sublimated into something dreamlike; yet she has a flush in her cheek and brooding sensuality.

FRONTISPIECE

Salvador Dali *(Spanish, born 1904)*

THE PERSISTENCE OF MEMORY 1931

Oil on canvas, 9½ × 13 in (24.1 × 33 cm)

Collection, The Museum of Modern Art, New York

SALVADOR DALI'S HAUNTING "hand-painted dream photographs," as he termed them, not only introduced a new objectivity into surrealism but also presented new subject matter and an elaborate scheme of rationalization for dealing with personal fantasy. When Dali joined the conflict-torn surrealist movement in 1929, his microscopically detailed, realist style and imagination provided a fresh and revitalizing force.

In *The Persistence of Memory* Dali has created an enigmatic scenario of soft watches, an arid landscape, and a monstrous fetal creature that is a slumbering self-portrait. The limp timepieces, both jewellike and putrescent in physical substance, reveal the contradictions in material states that the surrealists used to baffle the public. At their best, such paintings encapsulated the anxieties, obsessive eroticism, and magic of vivid dream imagery.